This book belongs to

...

T0176171

Illustrated by

Kerby Rosanes

A PLUME BOOK

imagimorphia

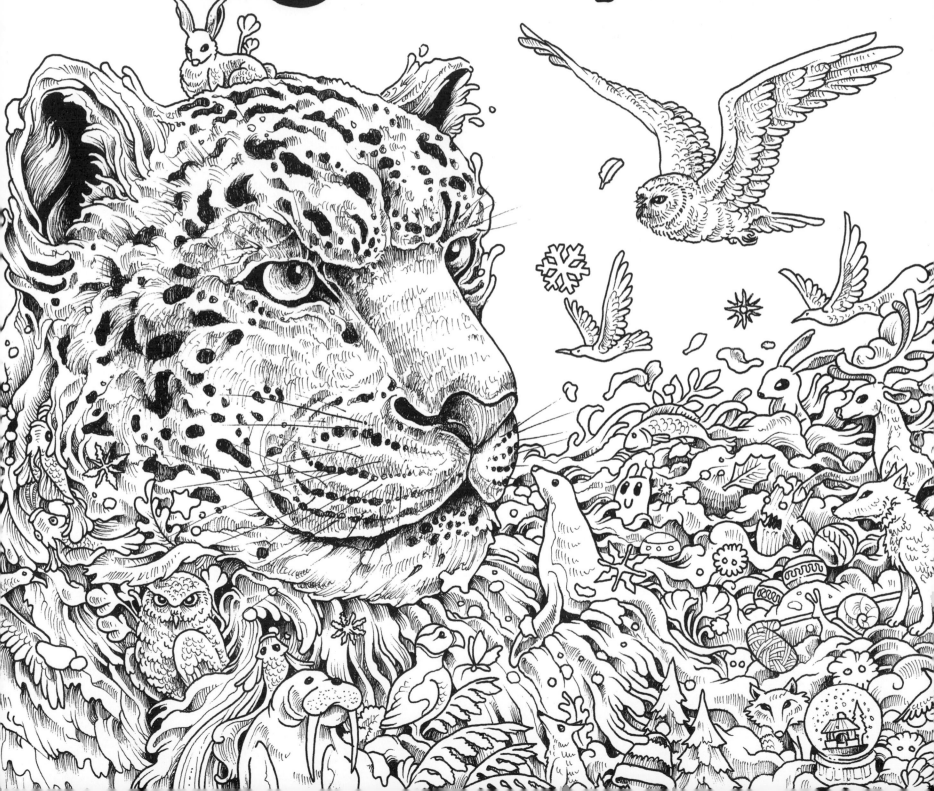

Edited by Sophie Schrey
Designed by Zoe Bradley

With thanks to Hannah Thornton
for being a great talent scout

PLUME
An imprint of Penguin Random House LLC
375 Hudson Street
New York, New York 10014

First published in Great Britain in 2016 by
LOM ART, an imprint of Michael O'Mara Books Limited,
9 Lion Yard, Tremadoc Road, London SW4 7NQ

P REGISTERED TRADEMARK—MARCA REGISTRADA

978-0-399-57412-2

Printed in China
12

Get ready for an imaginative coloring adventure!

Dive into my high-definition, super-detailed doodle world, where animals, objects, and landscapes explode and morph into astounding detail.

Each intricate illustration has been hand-drawn using fineliner pens and can be colored in any way you like.

Look out for amazing objects scattered throughout the pages. You'll find a list of hidden treasures that you need to search for at the back of the book (along with all the answers).

Kerby Rosanes

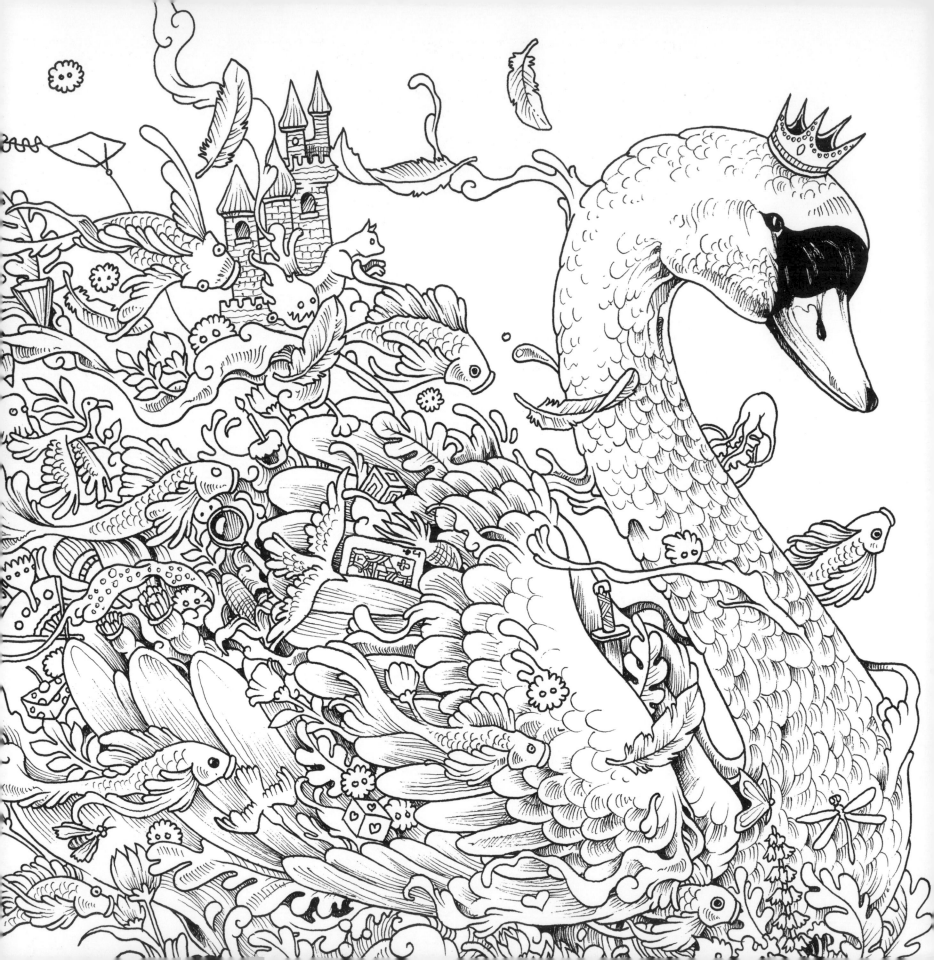

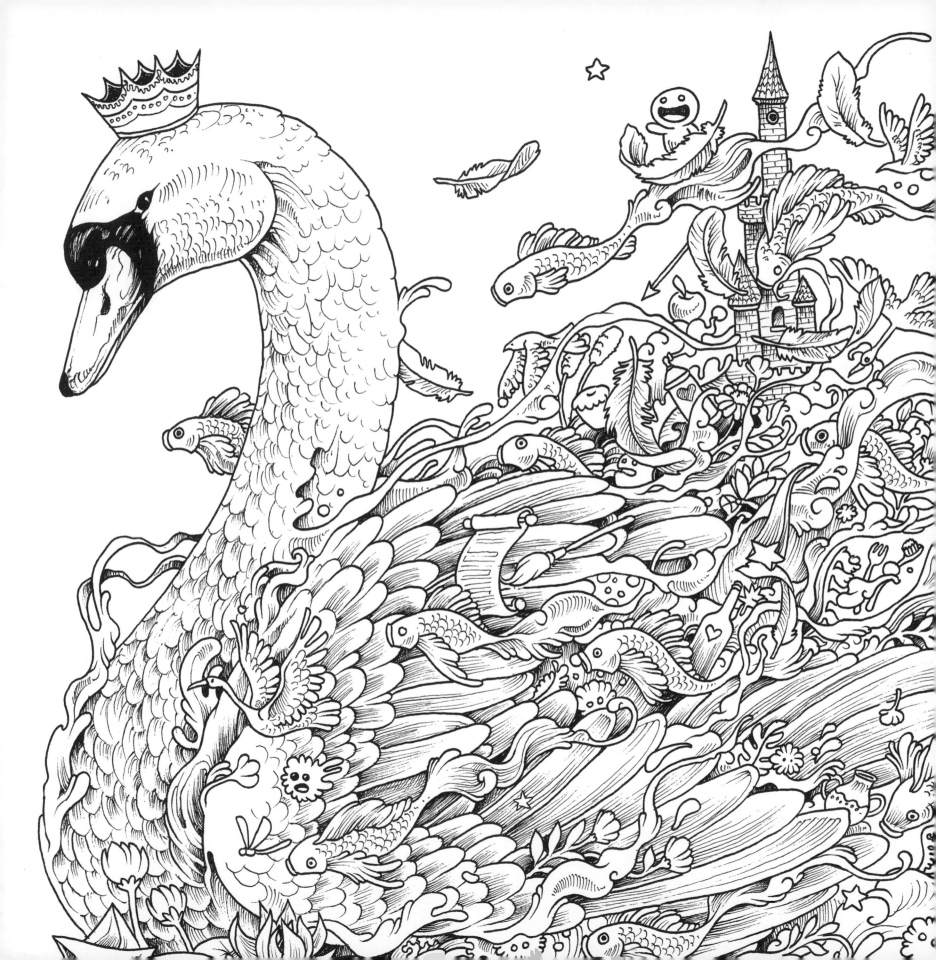

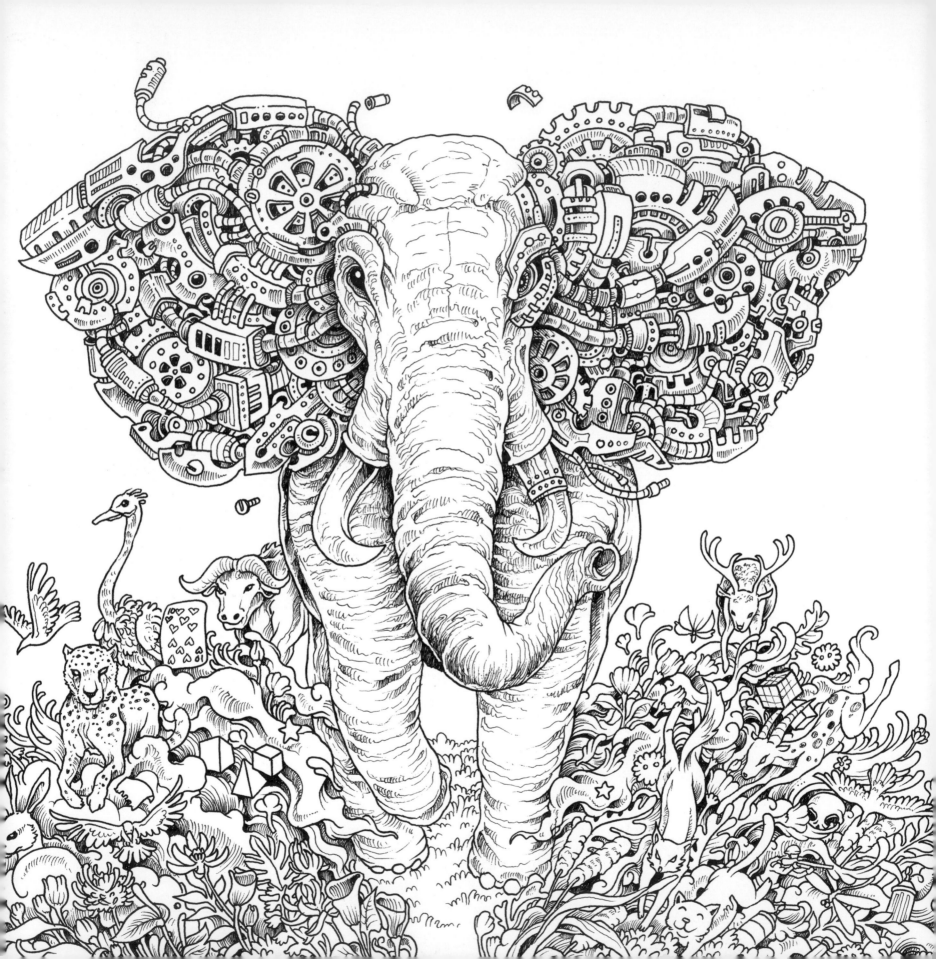

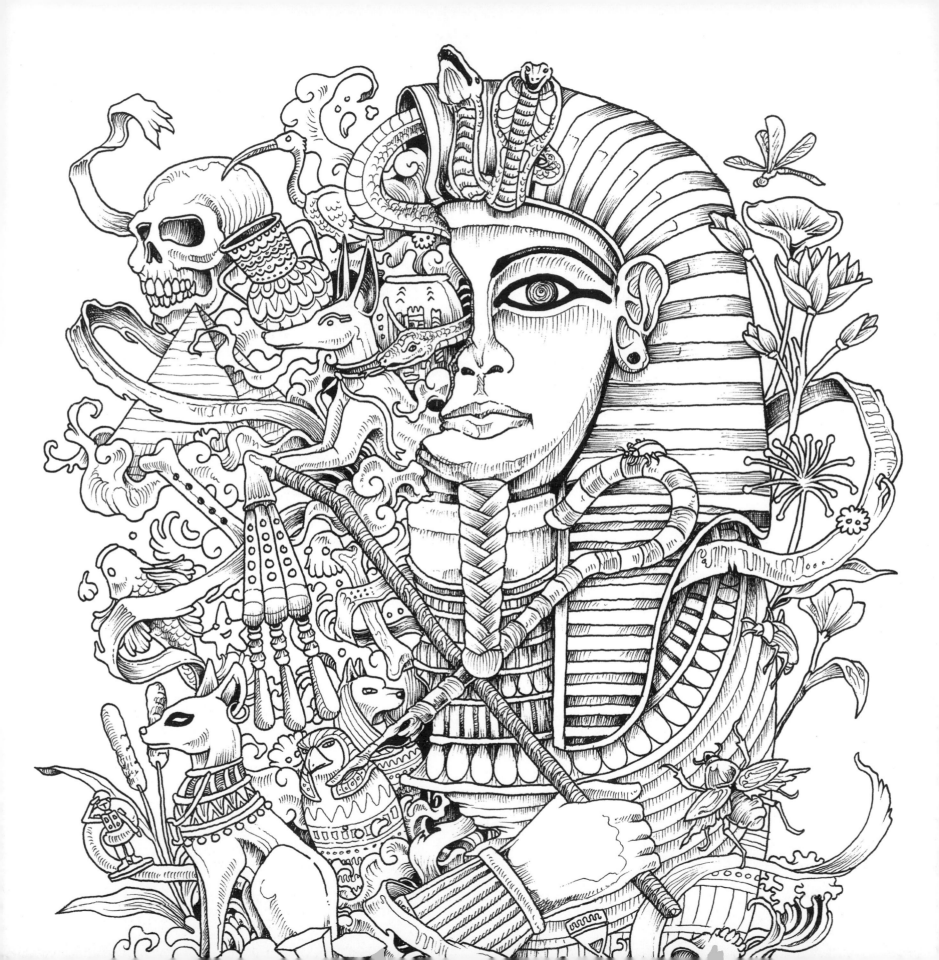

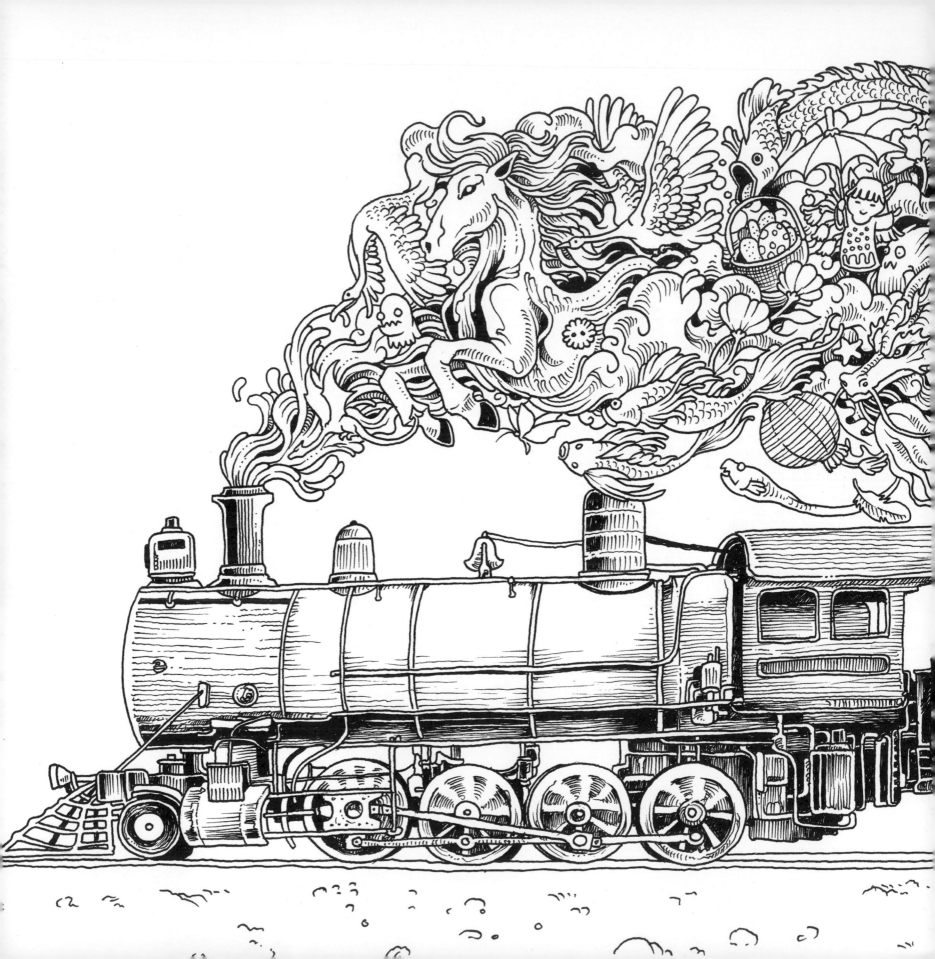

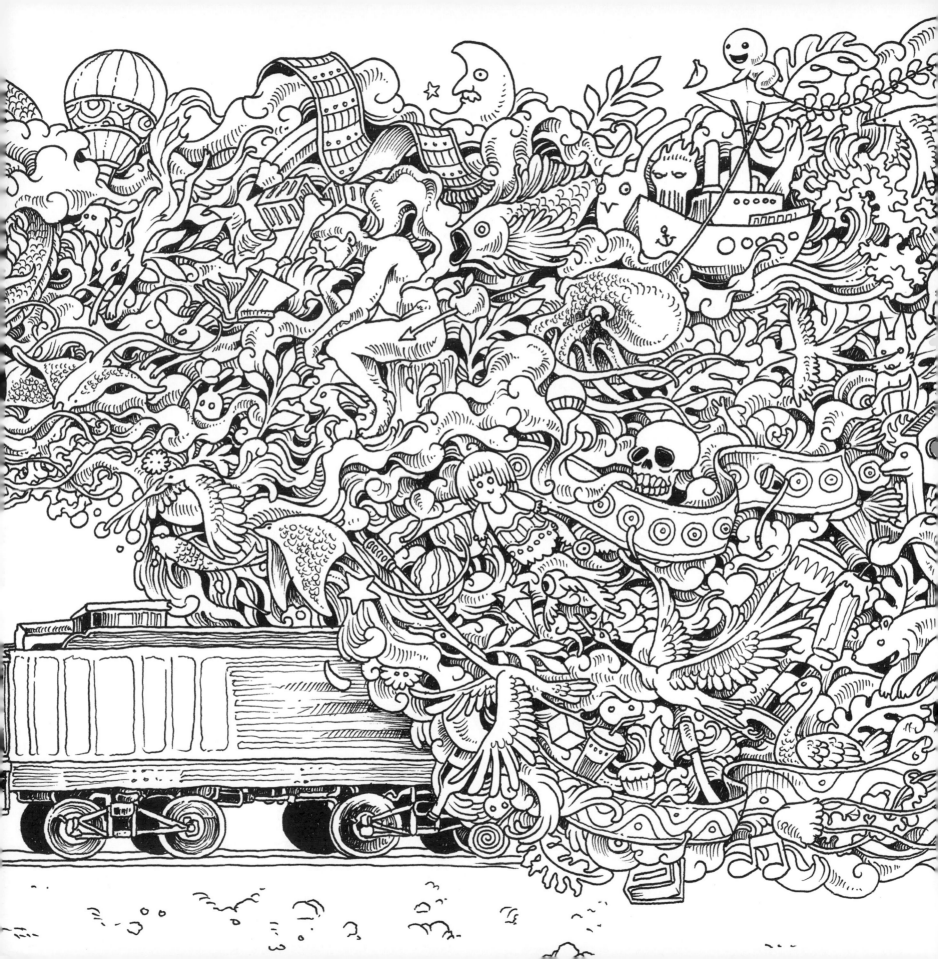

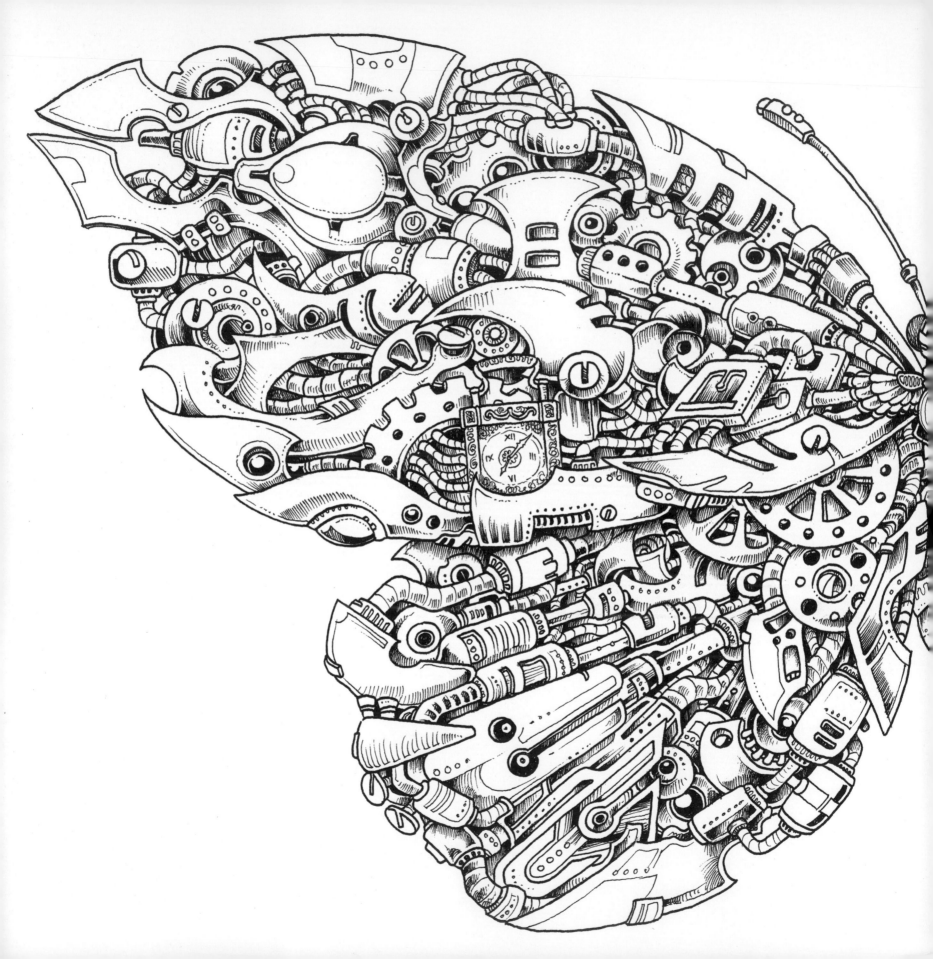

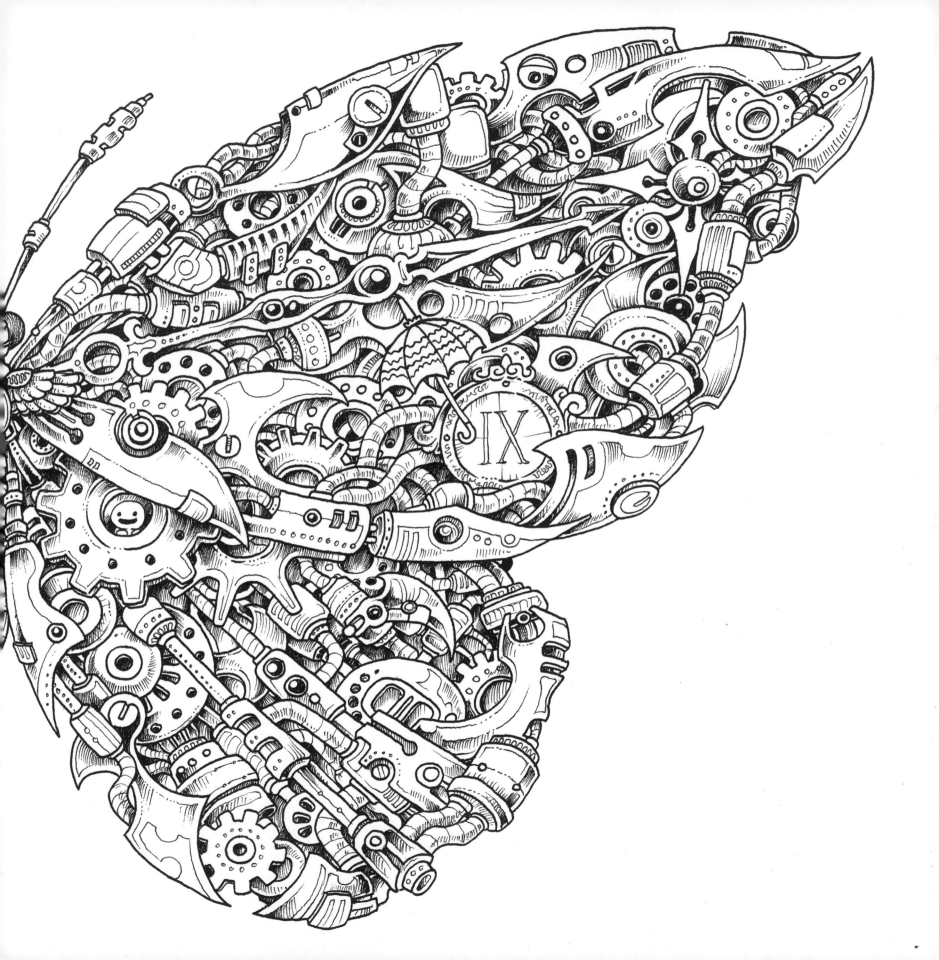

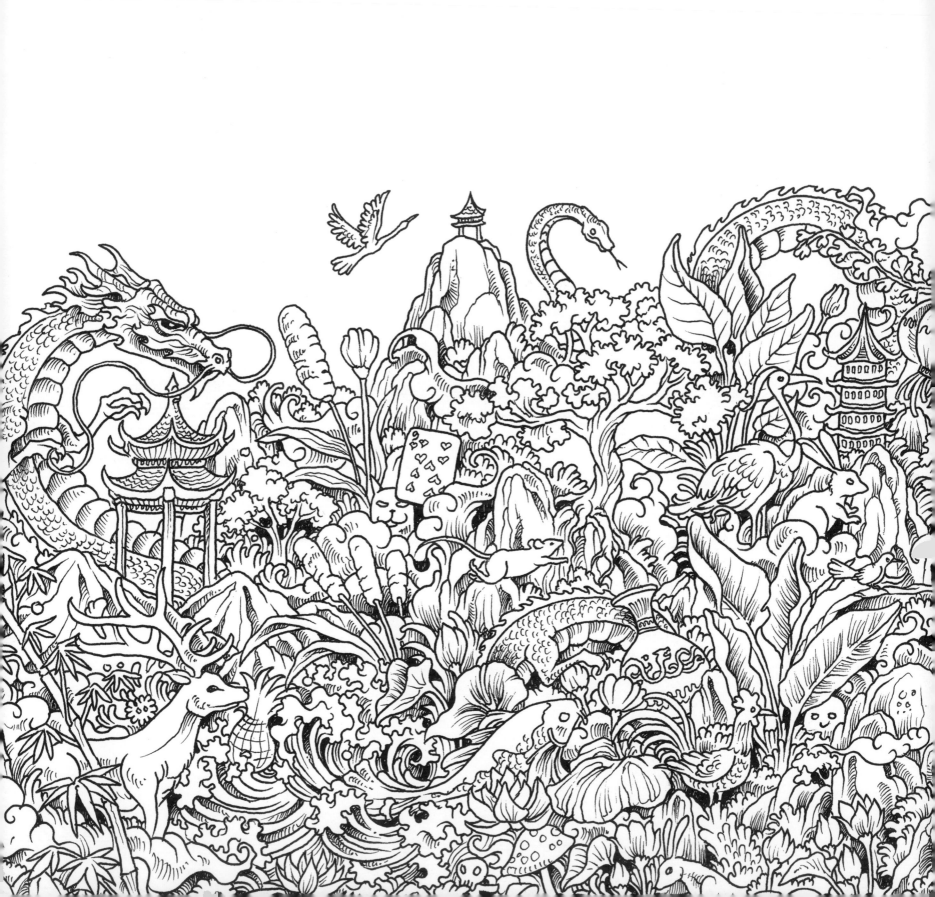

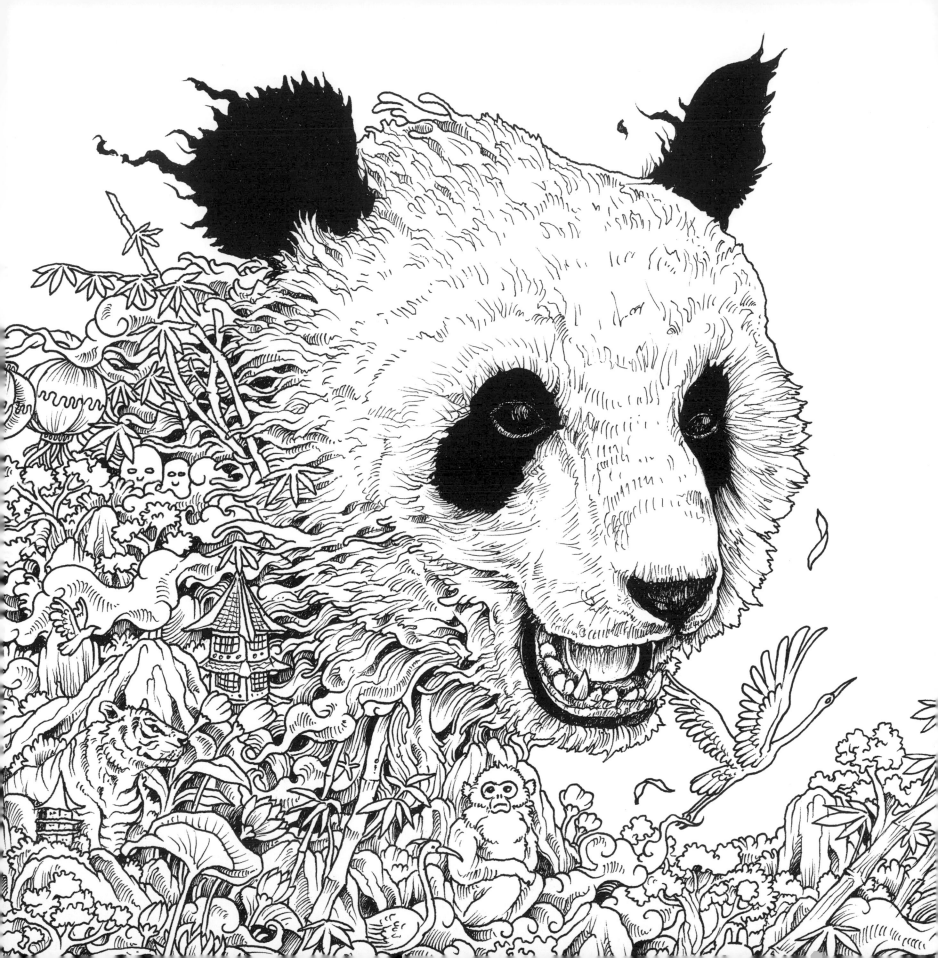

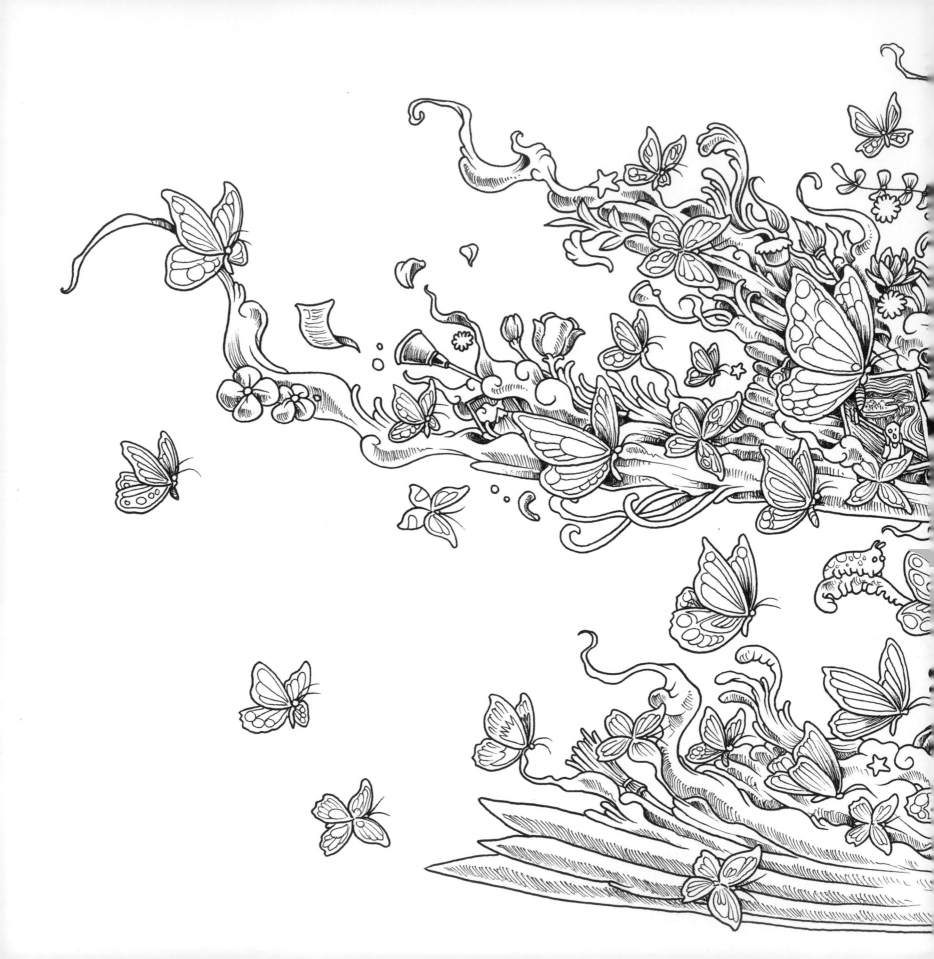

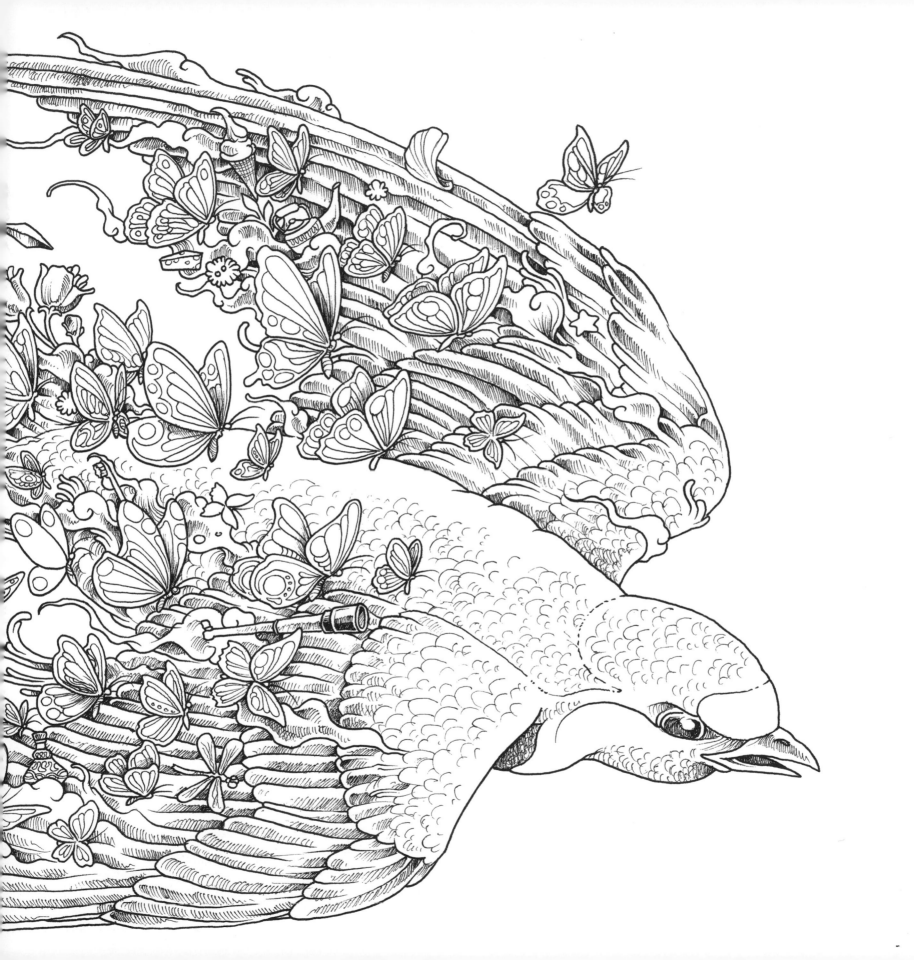

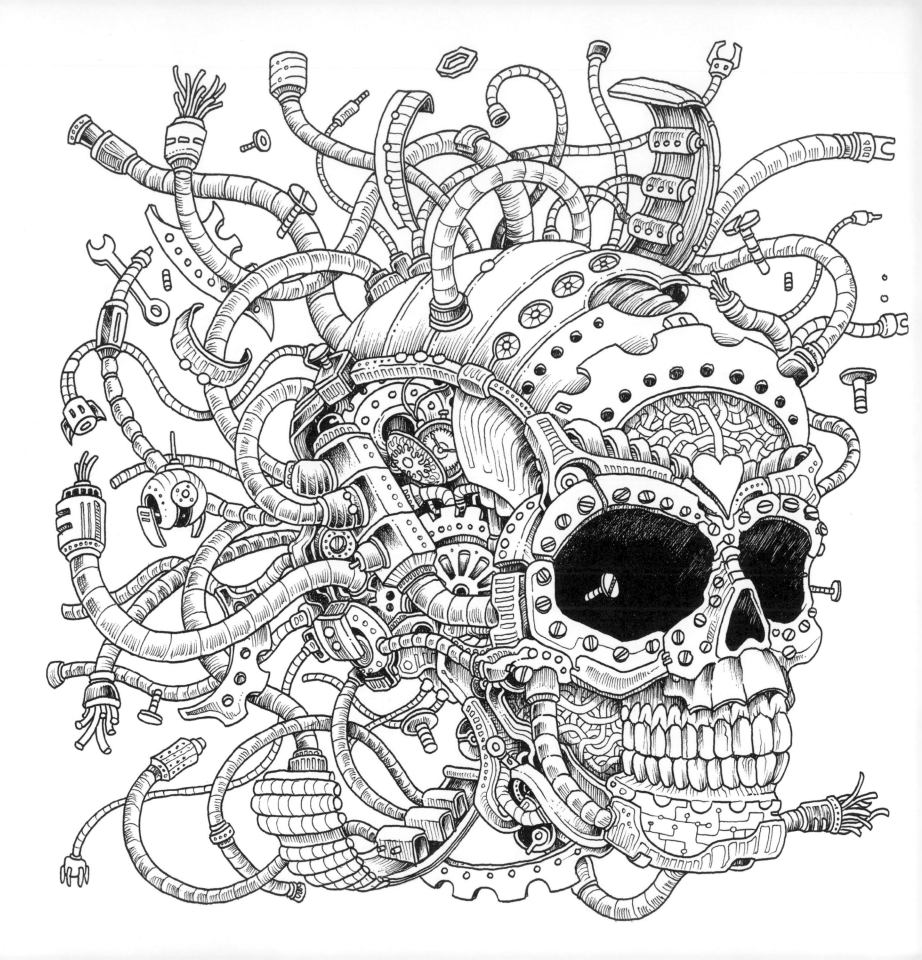

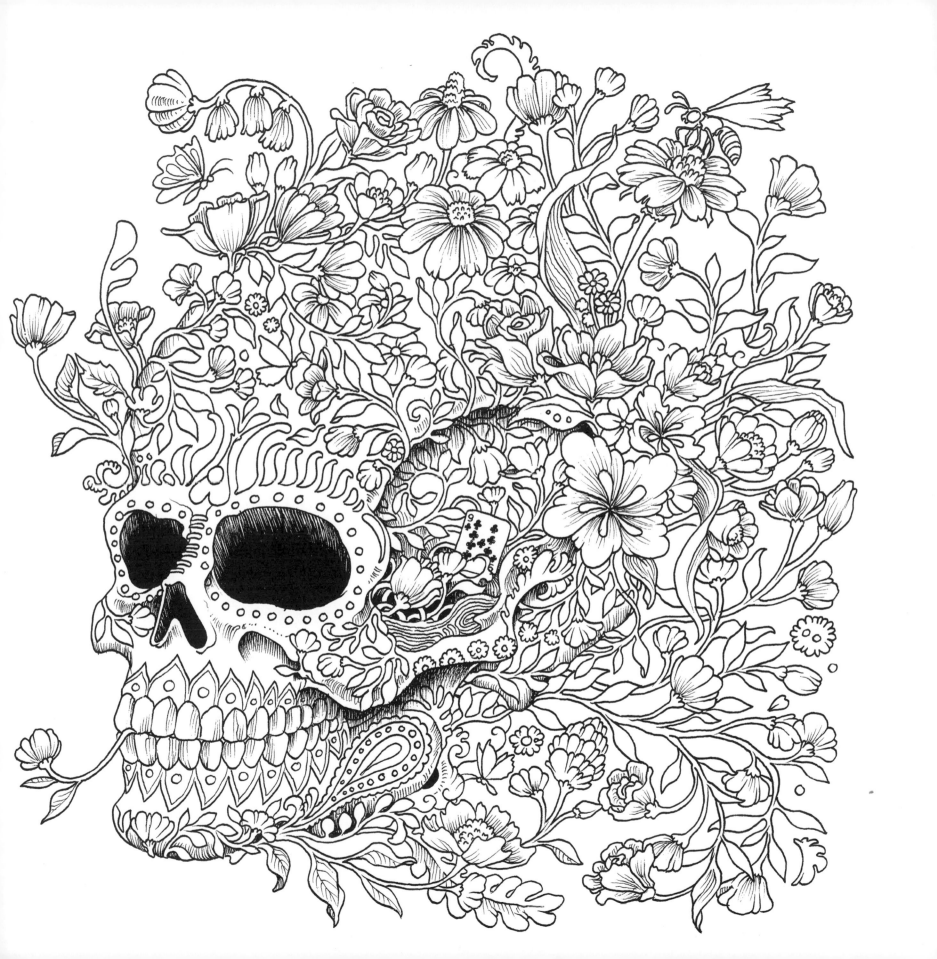

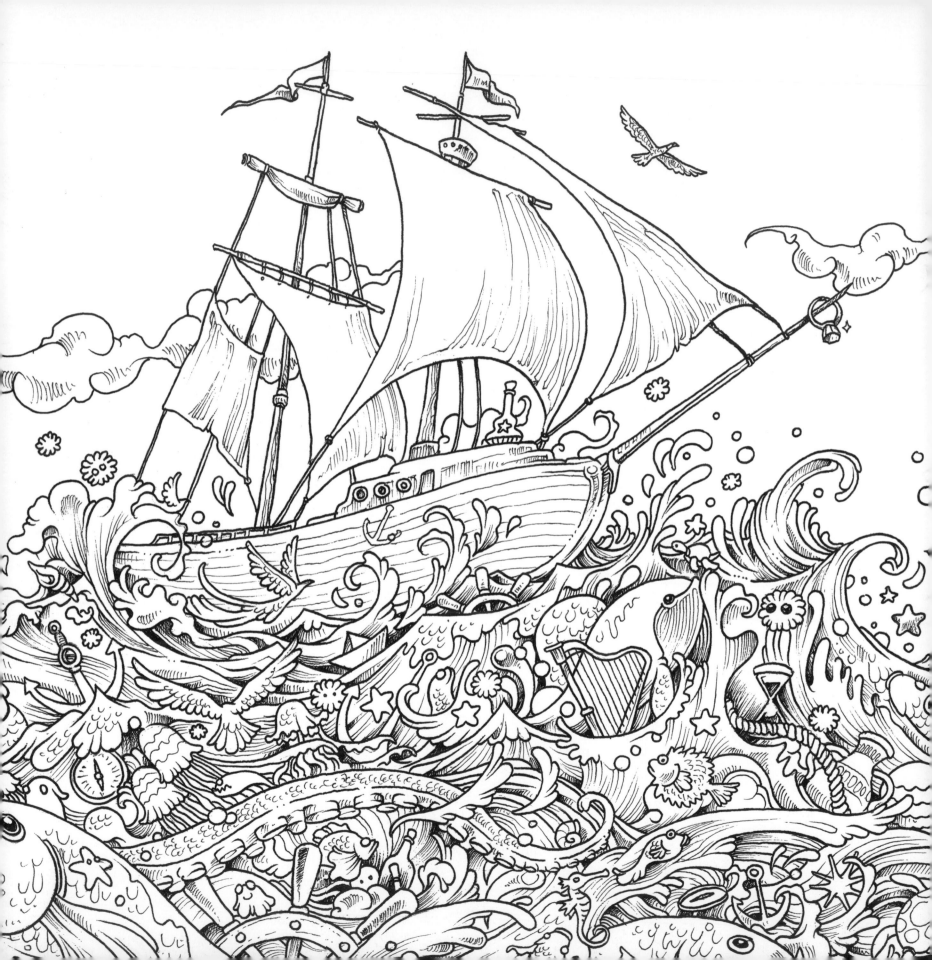

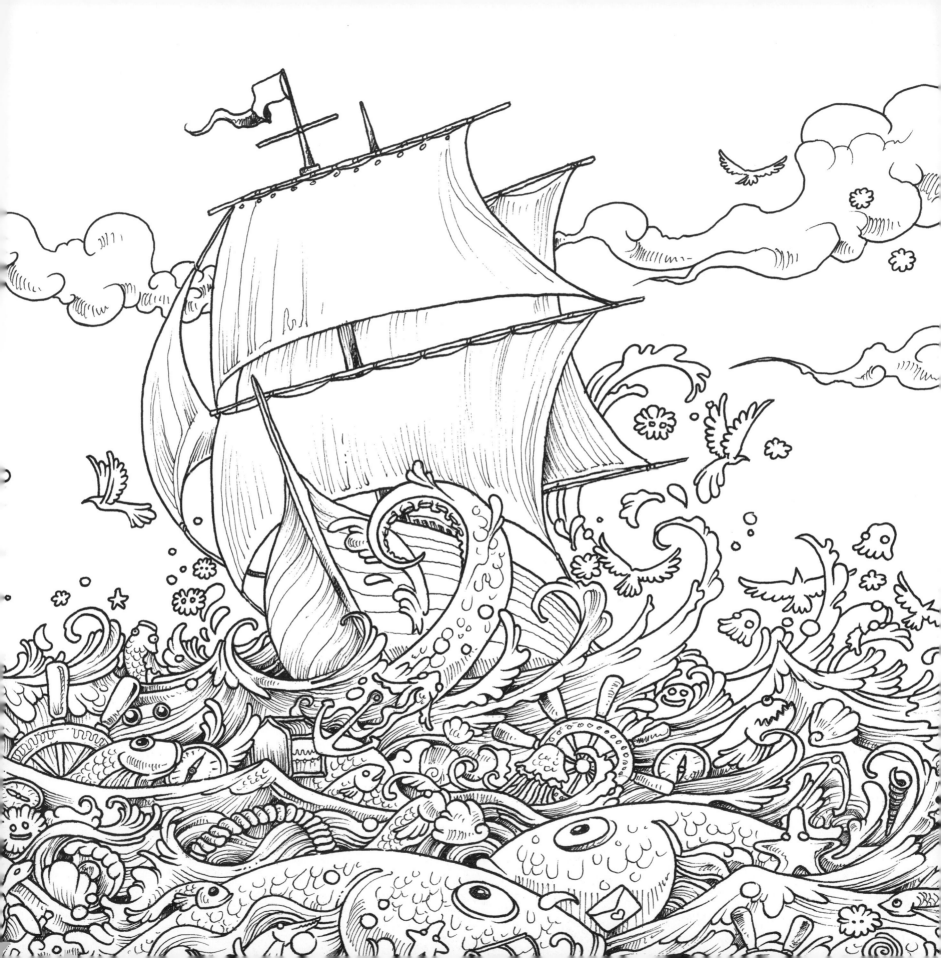

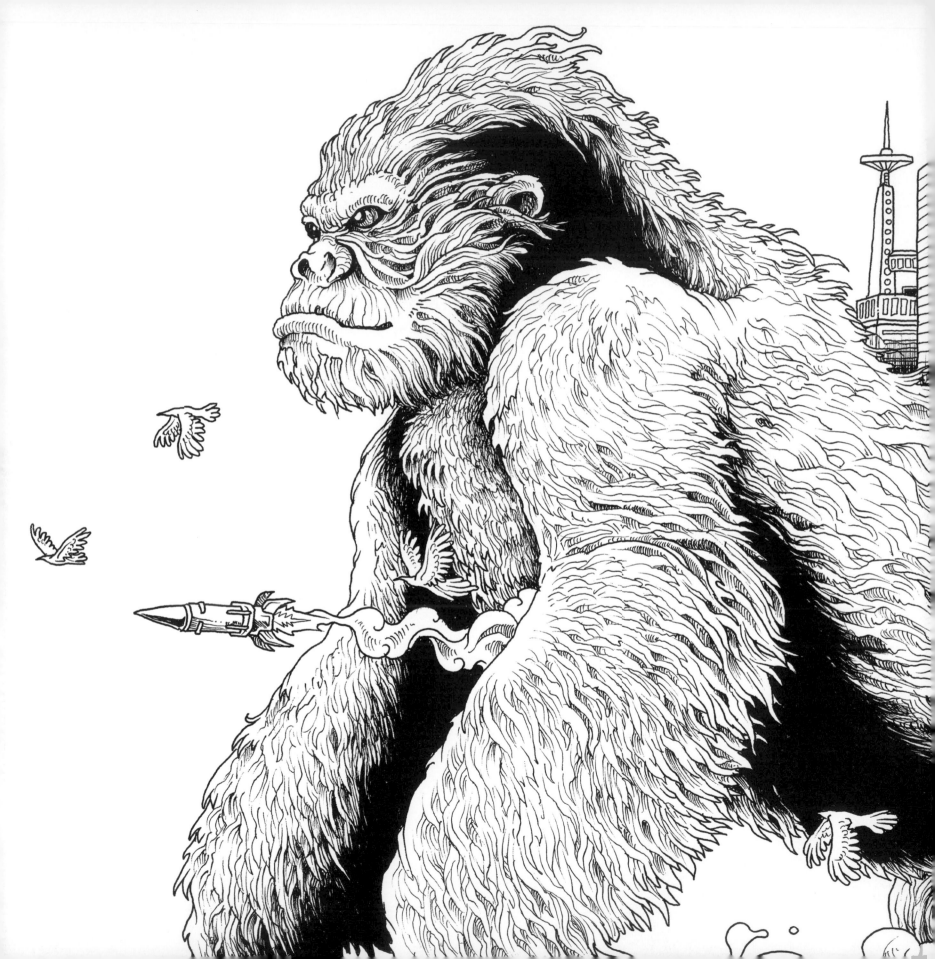

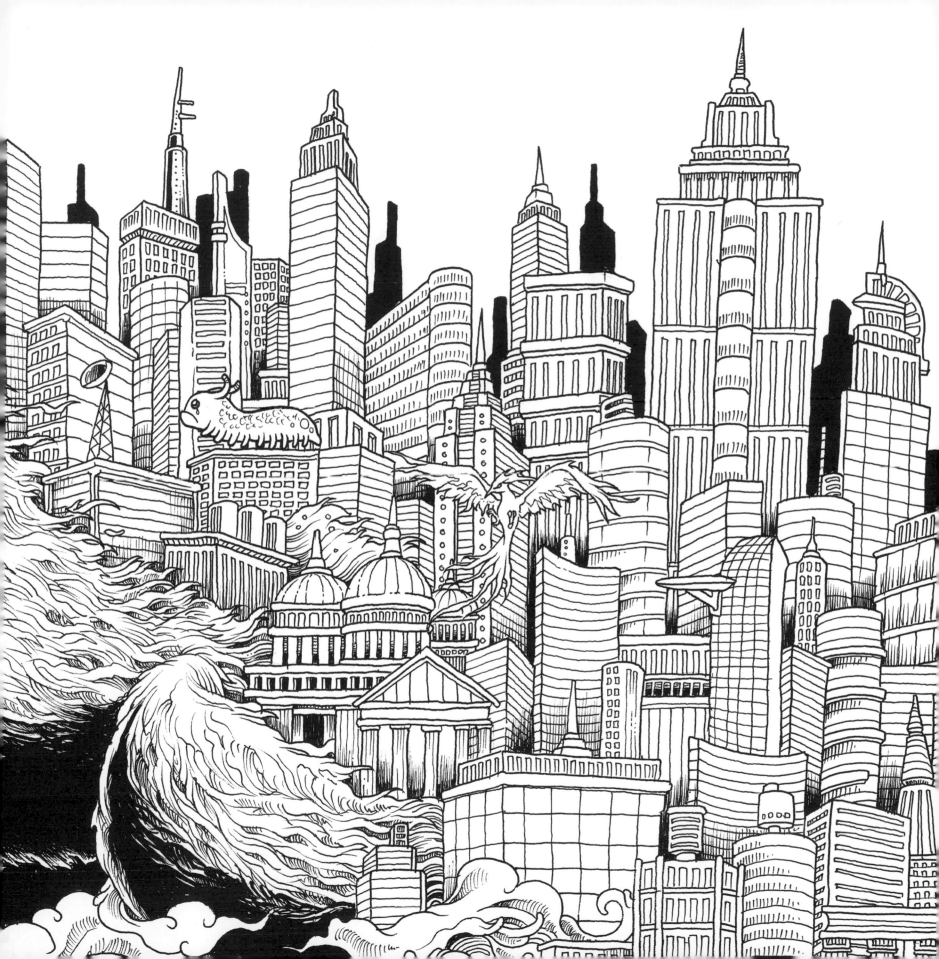

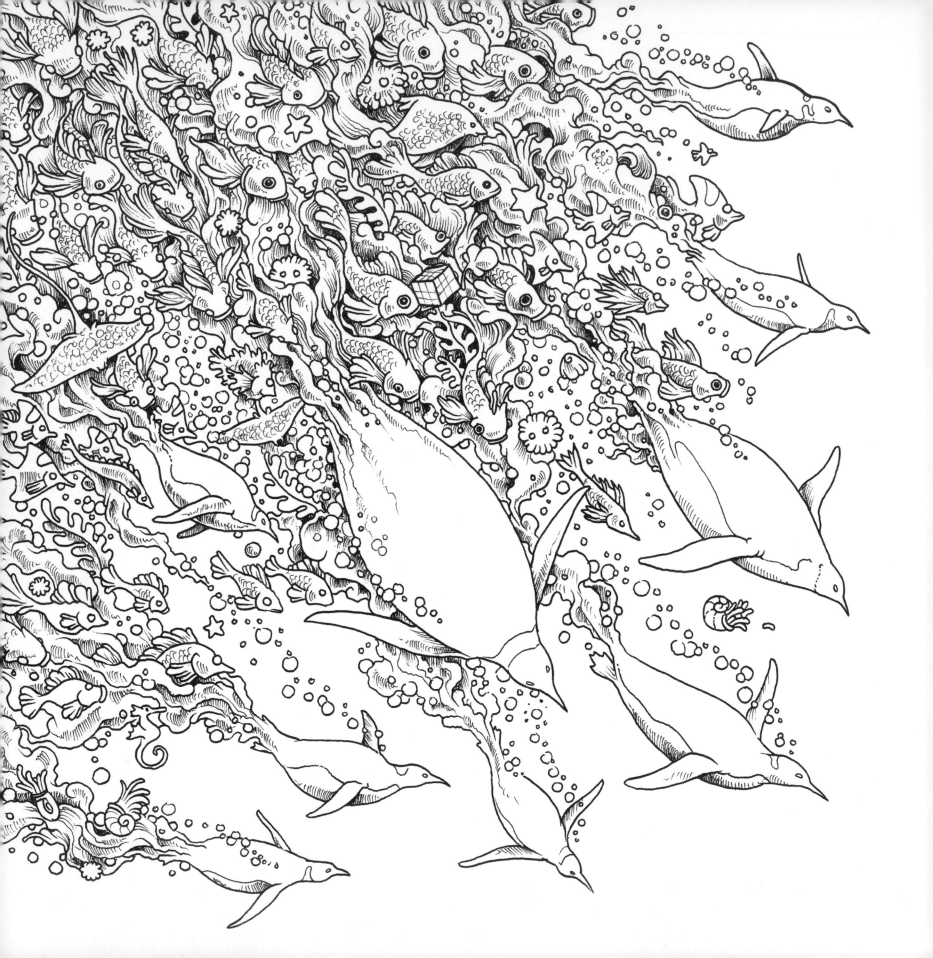

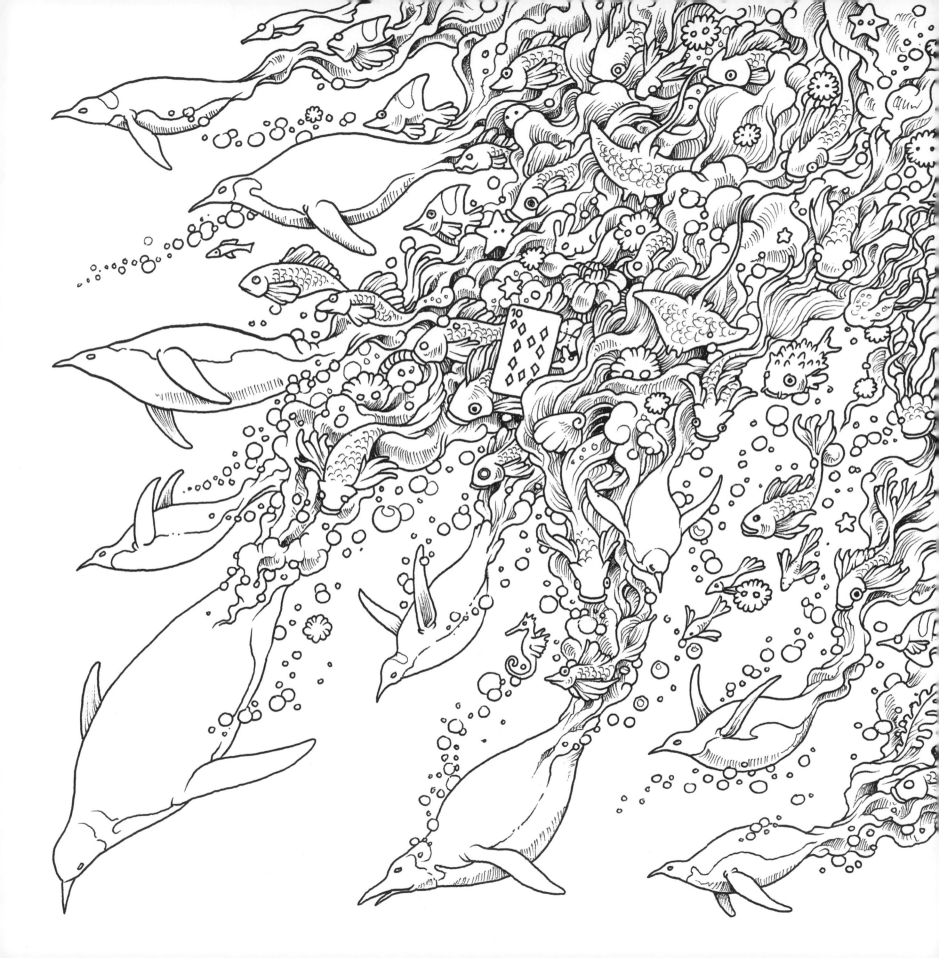

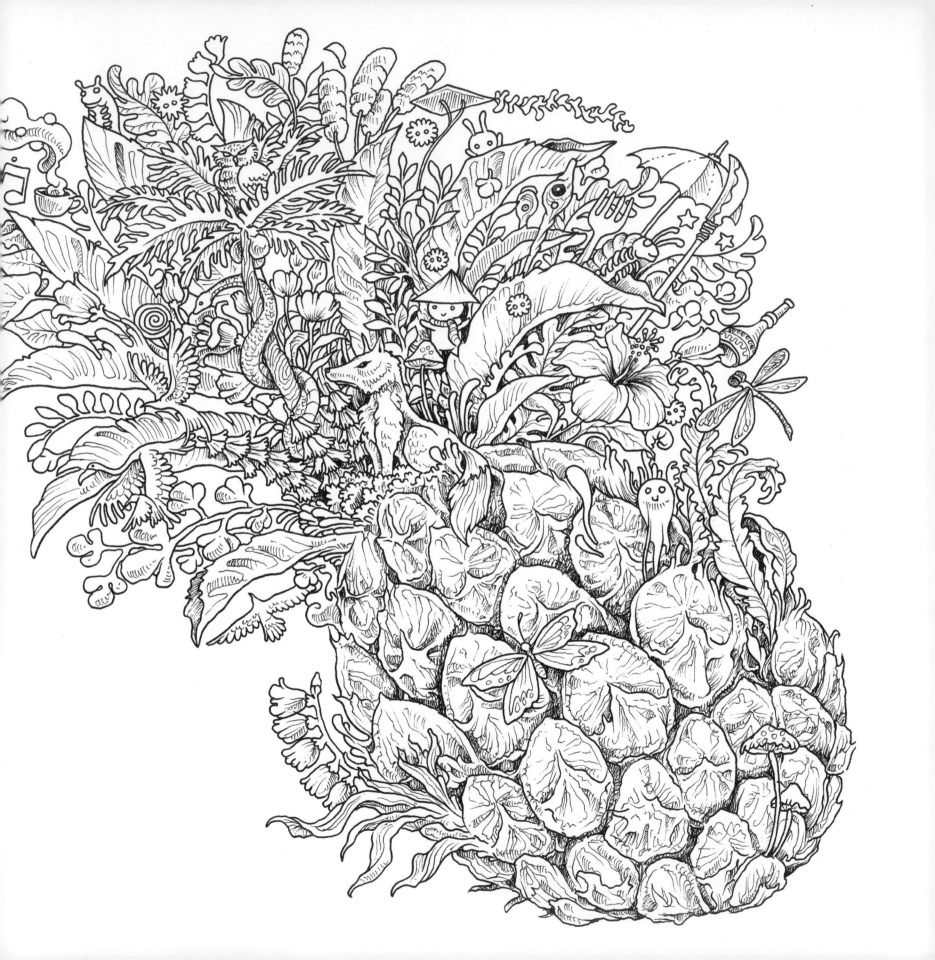

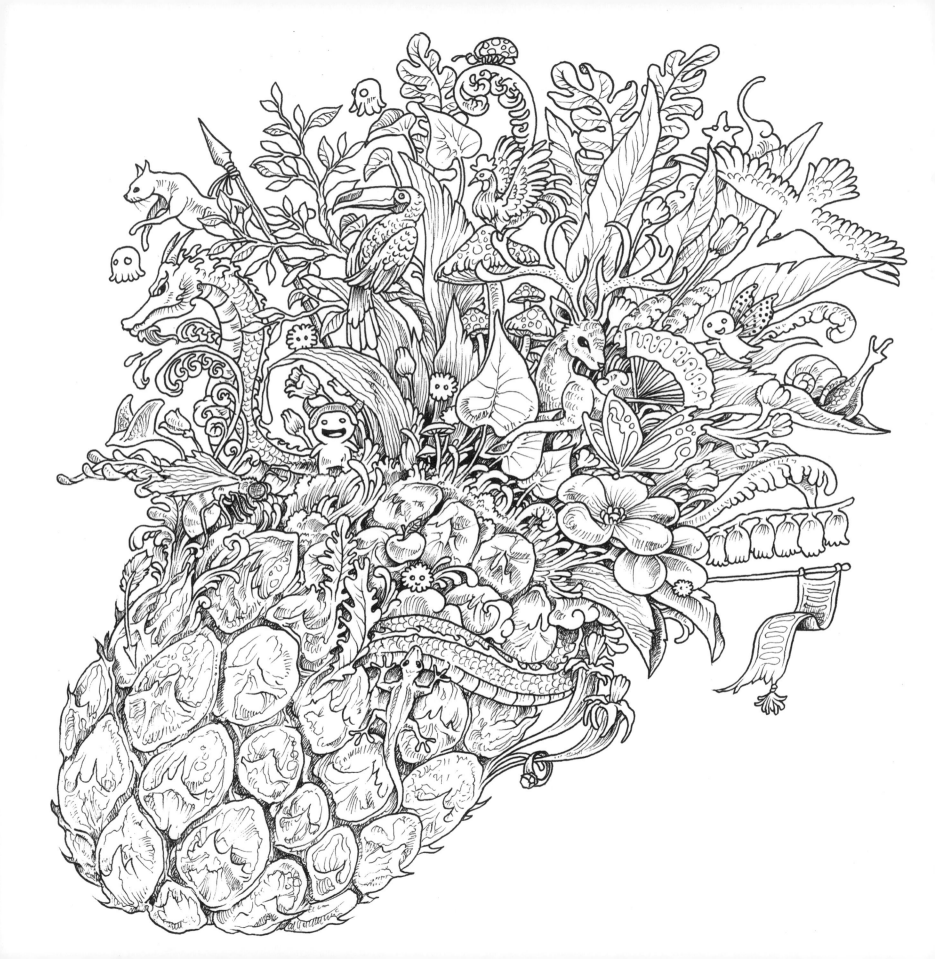

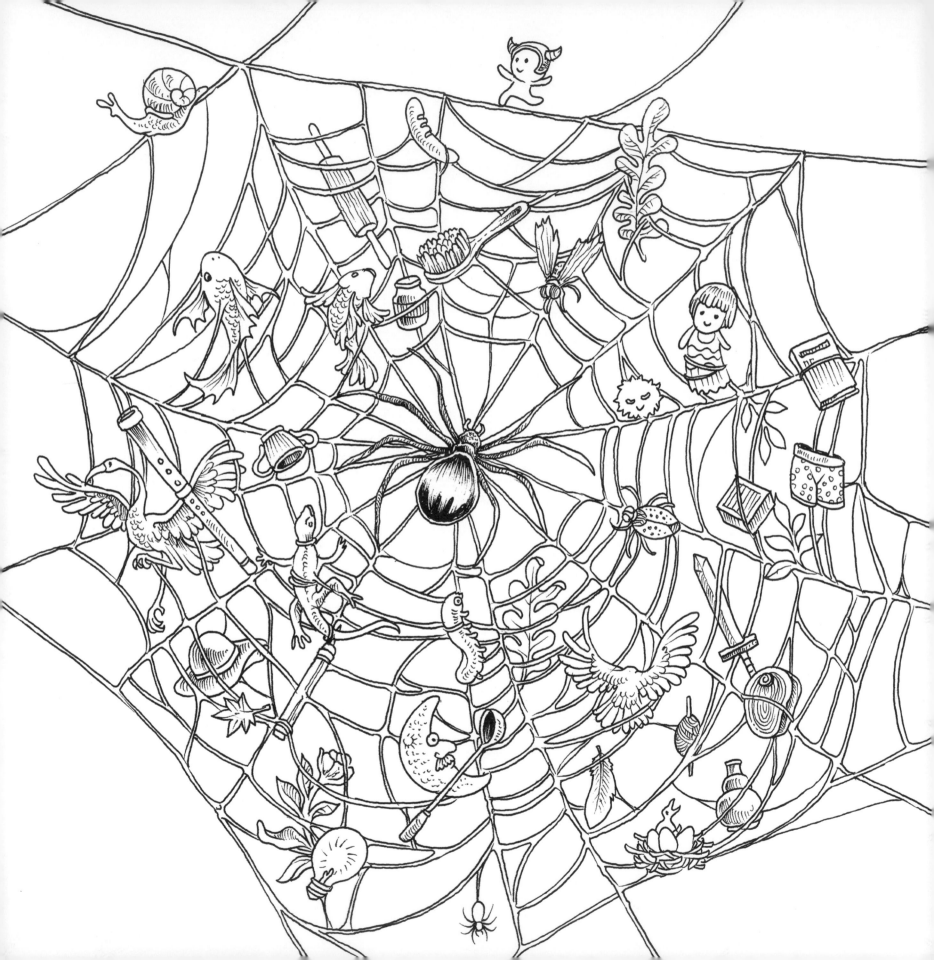

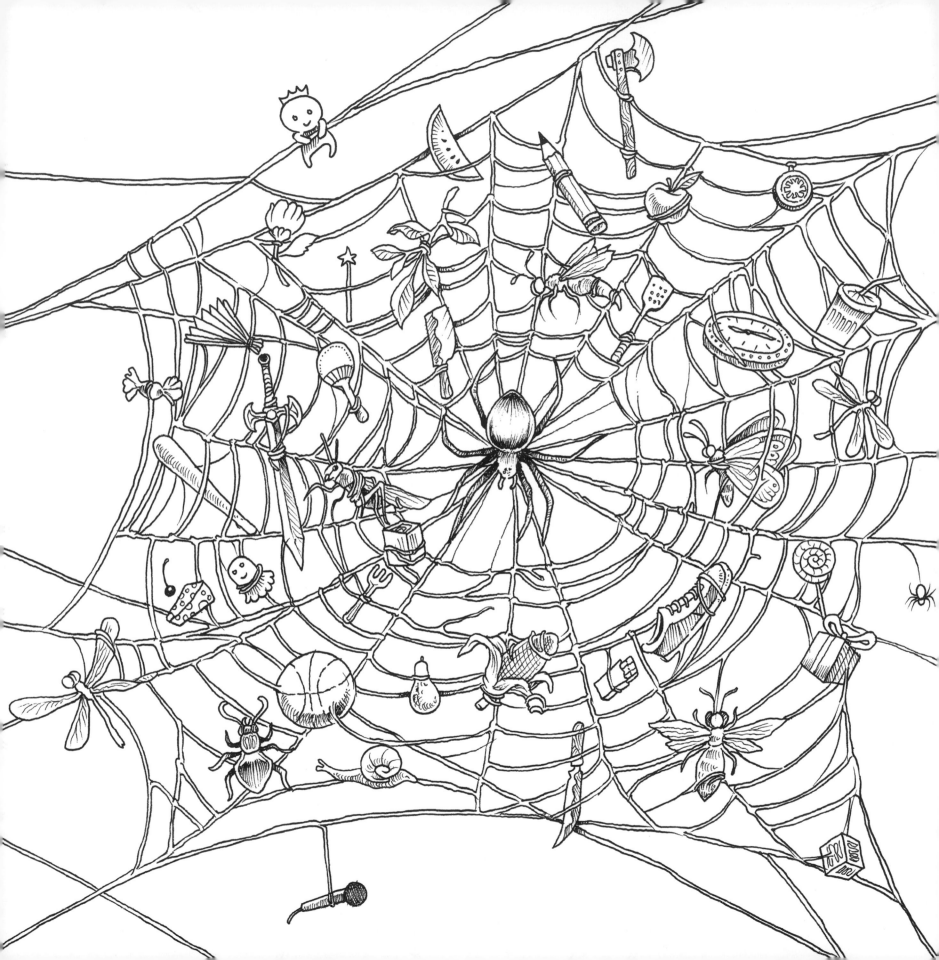

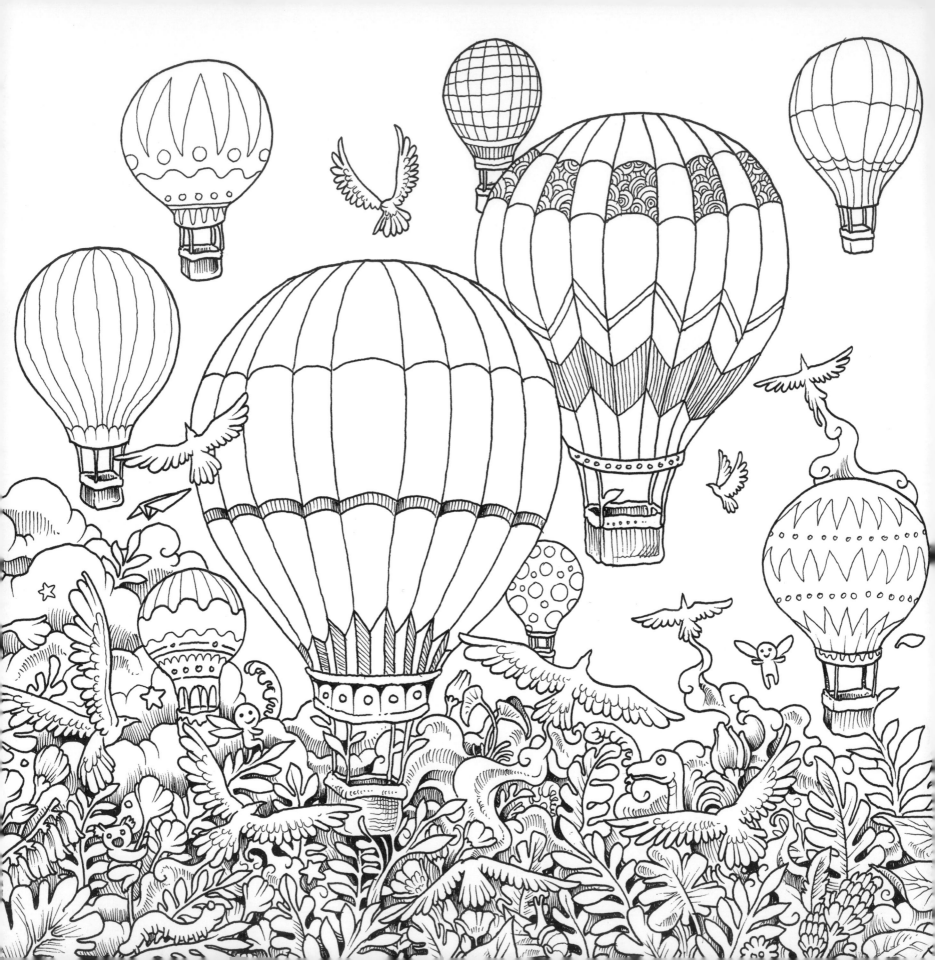

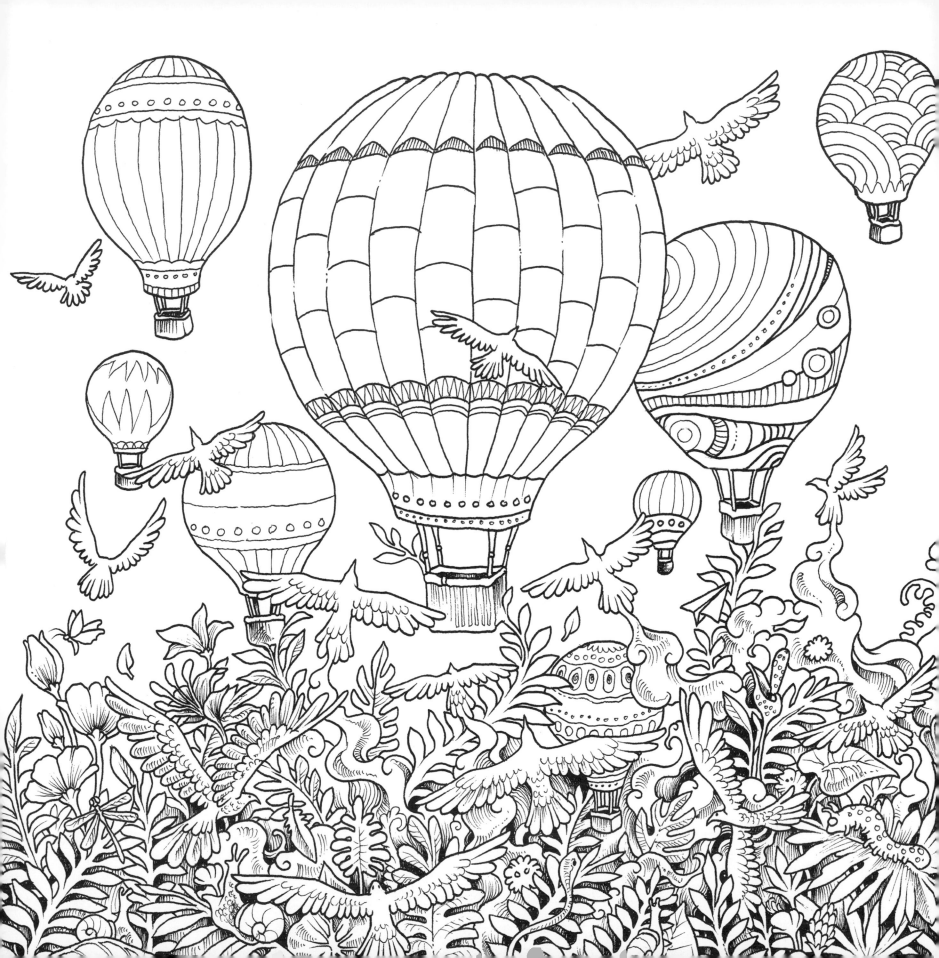

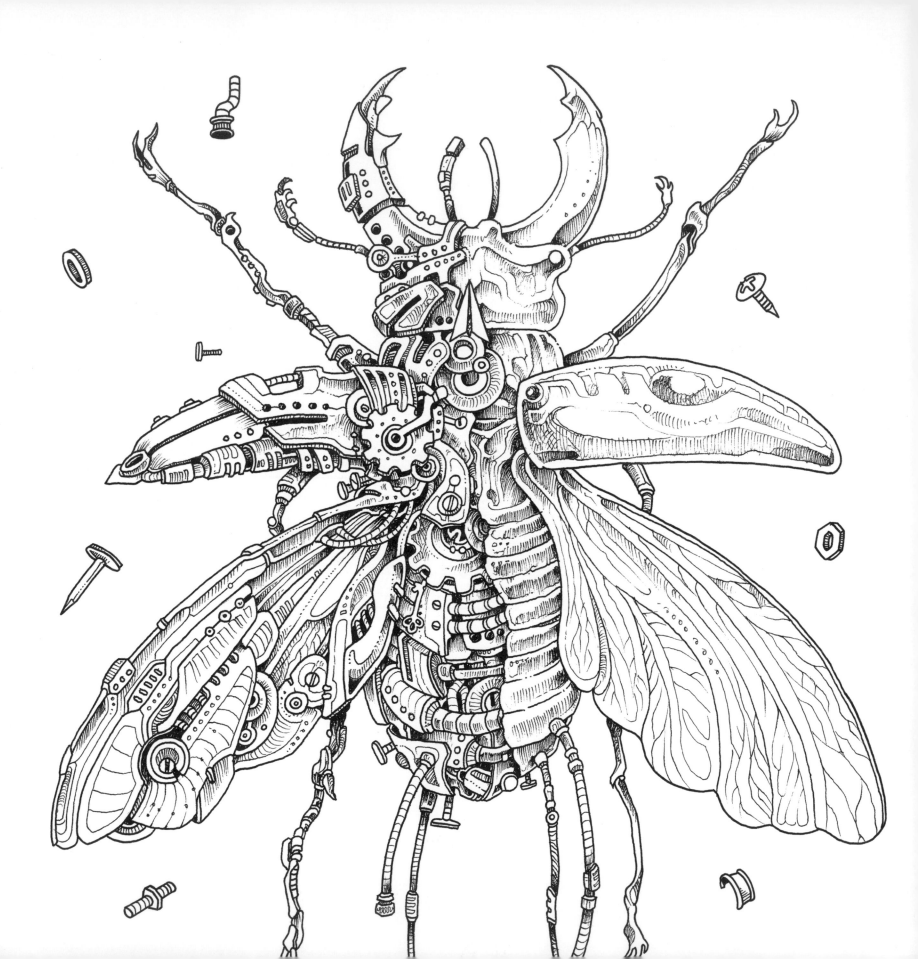

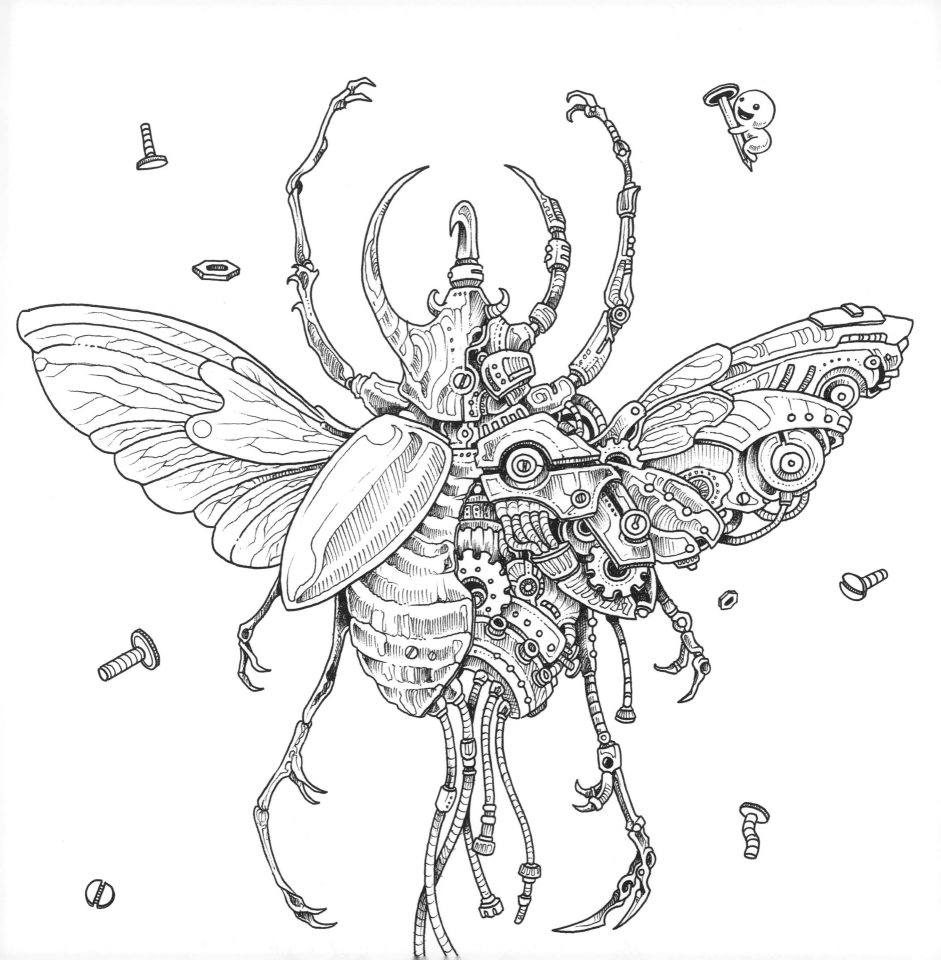

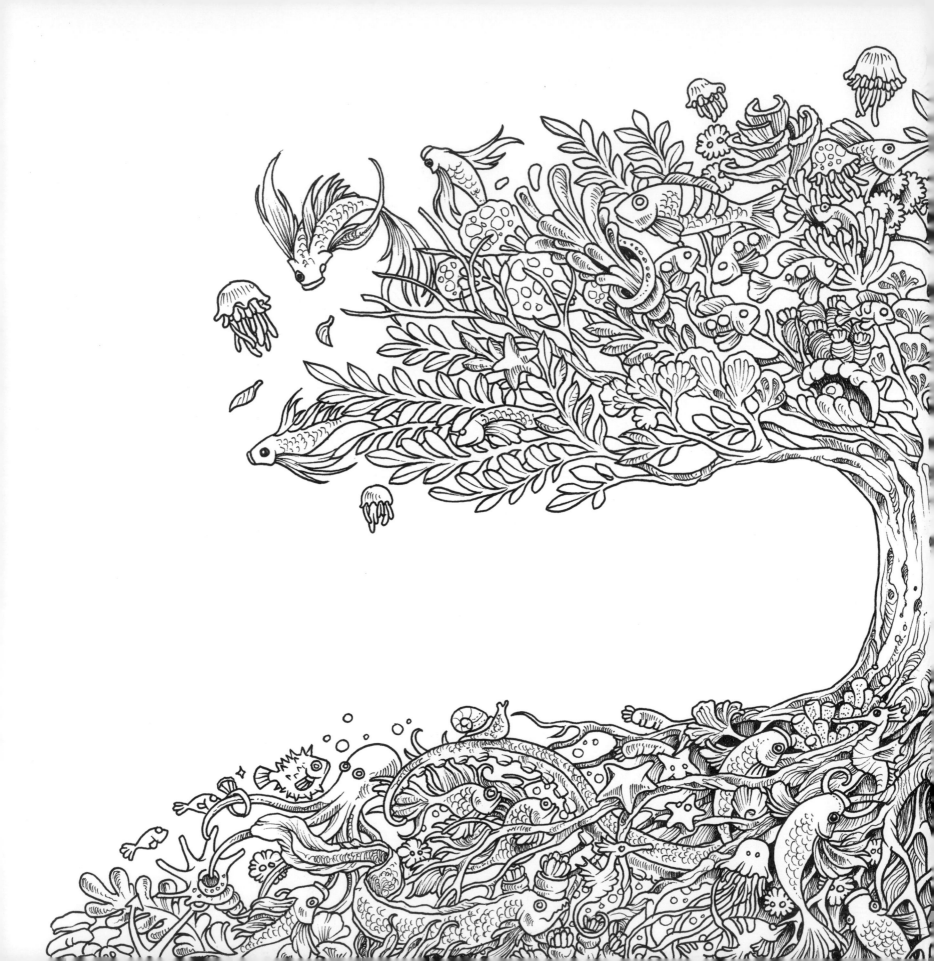

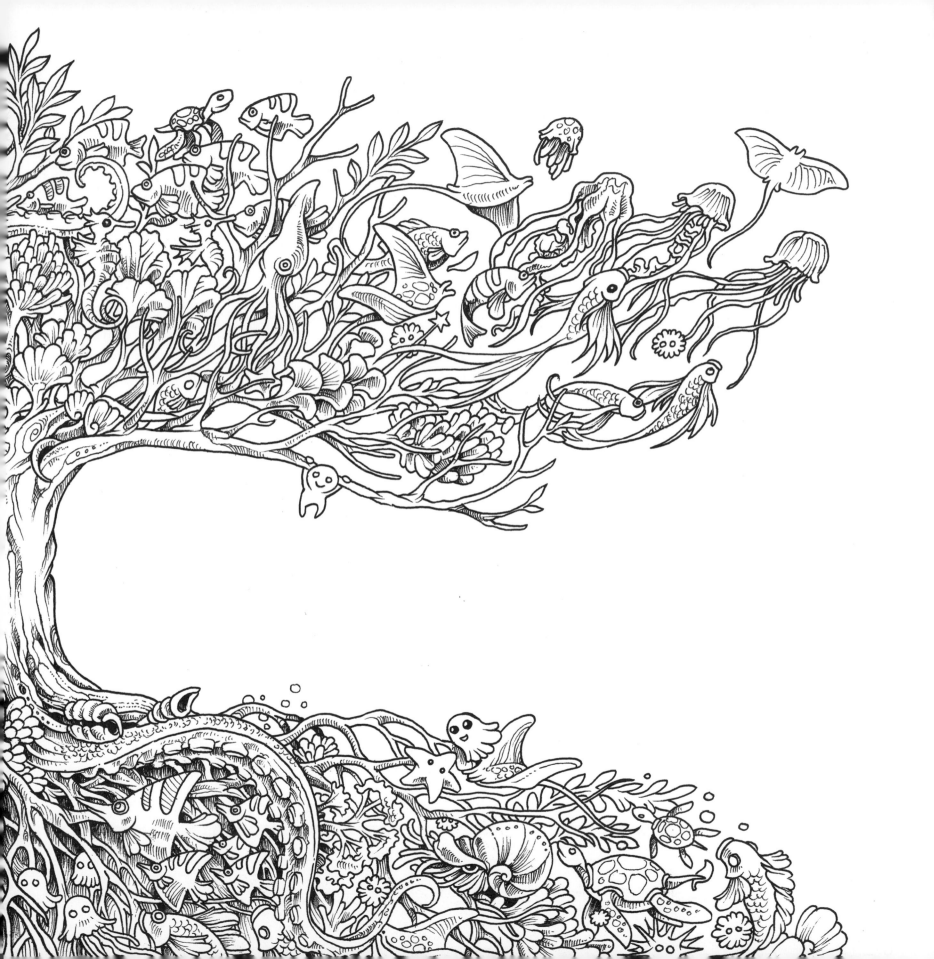

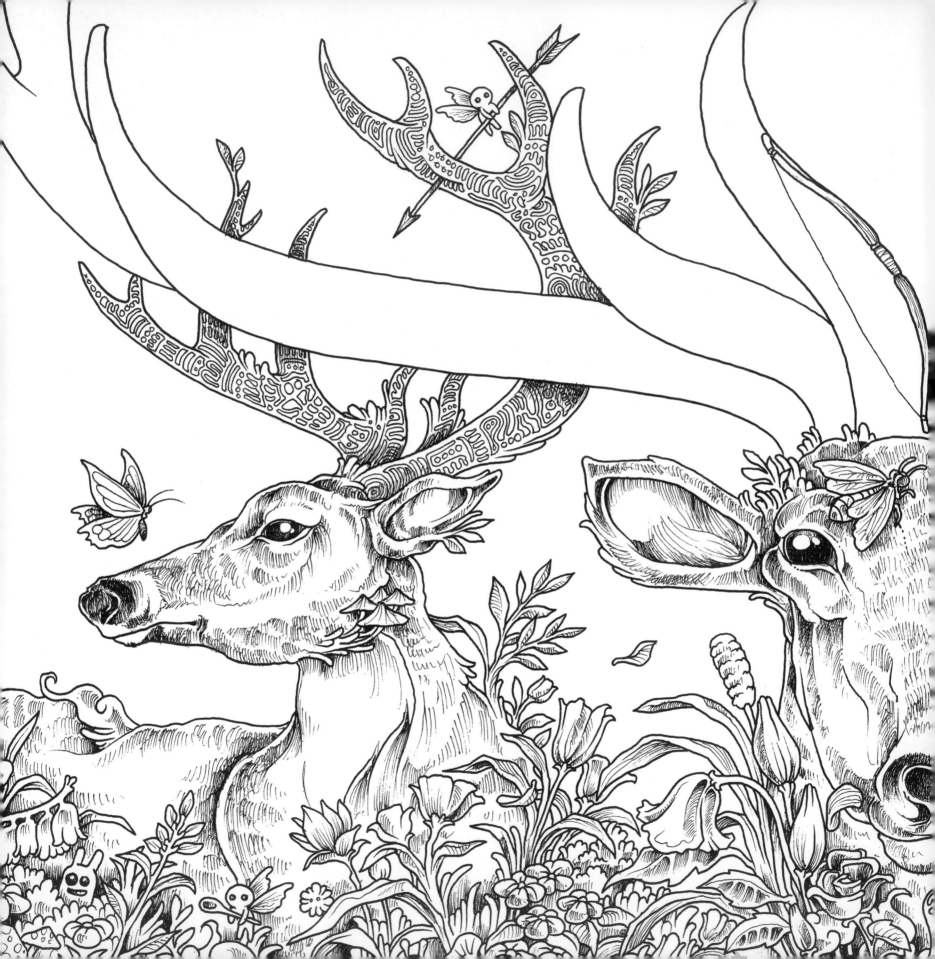

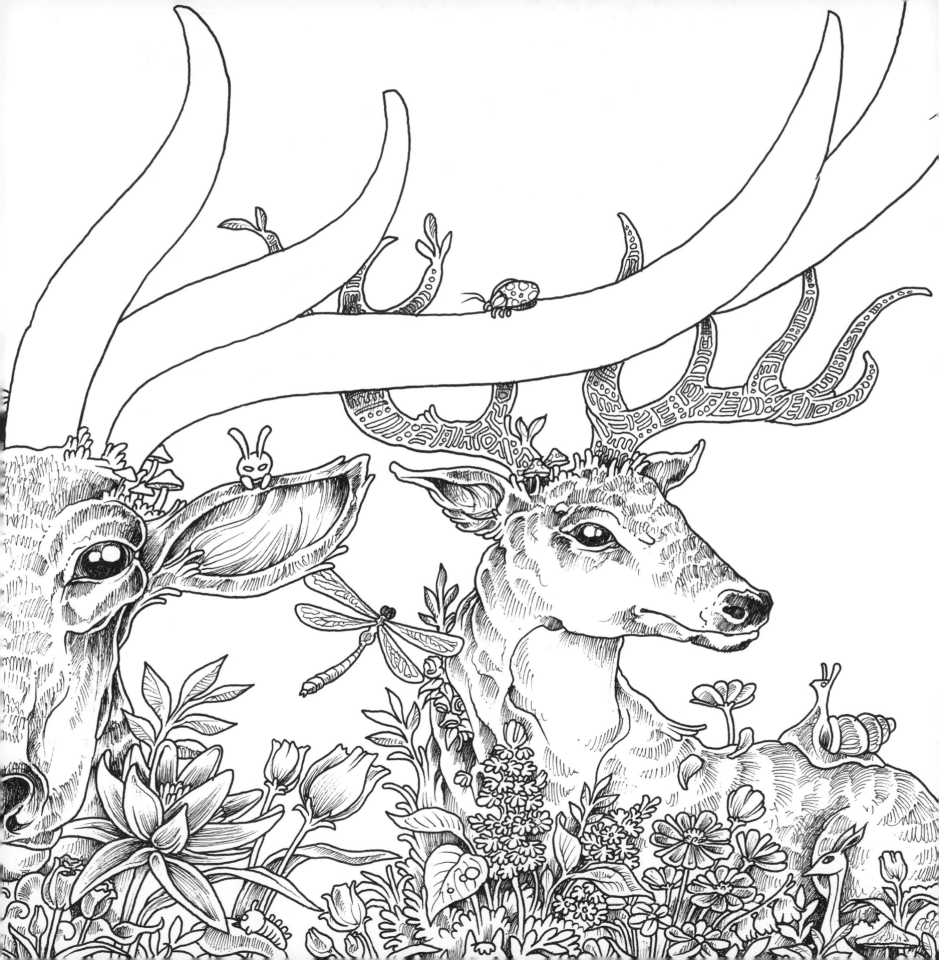

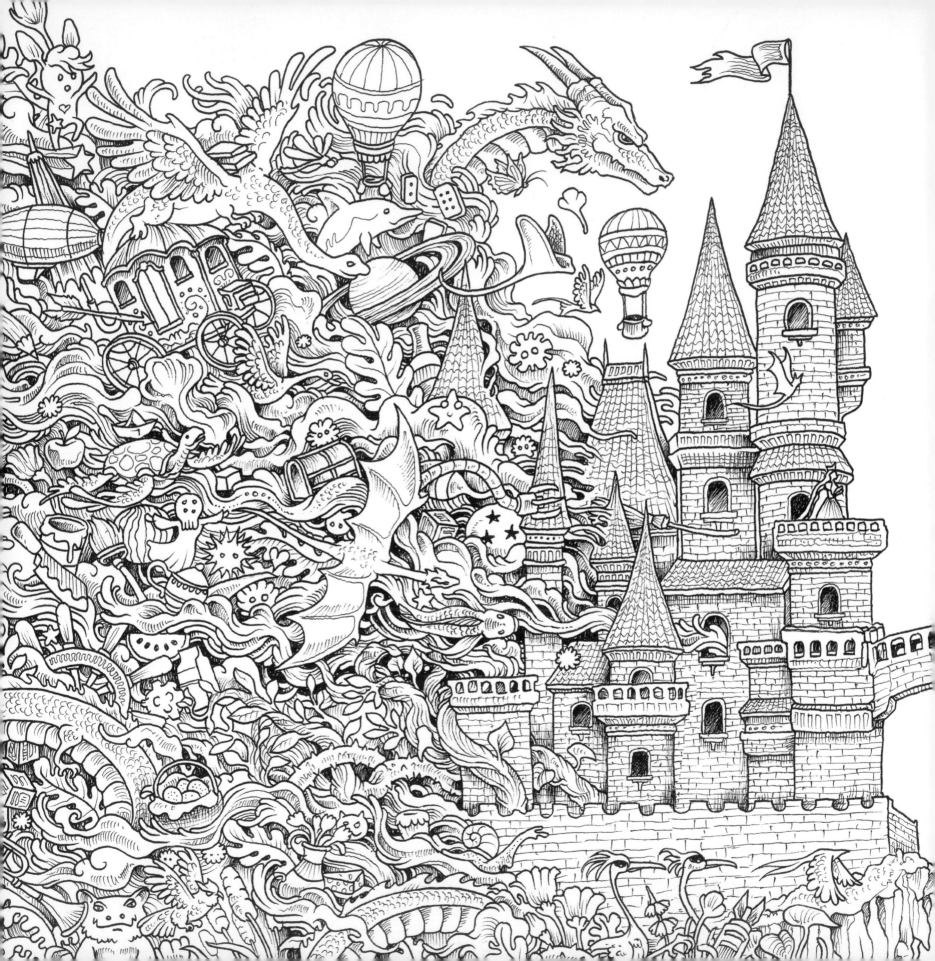

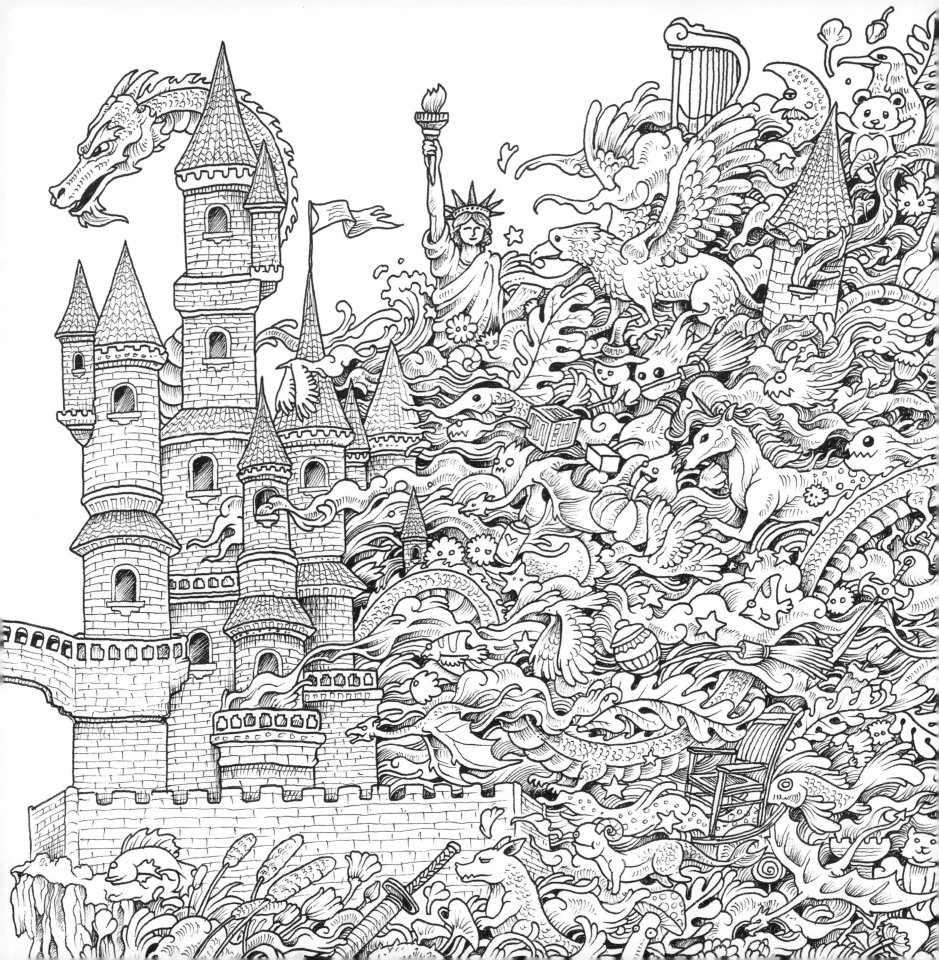

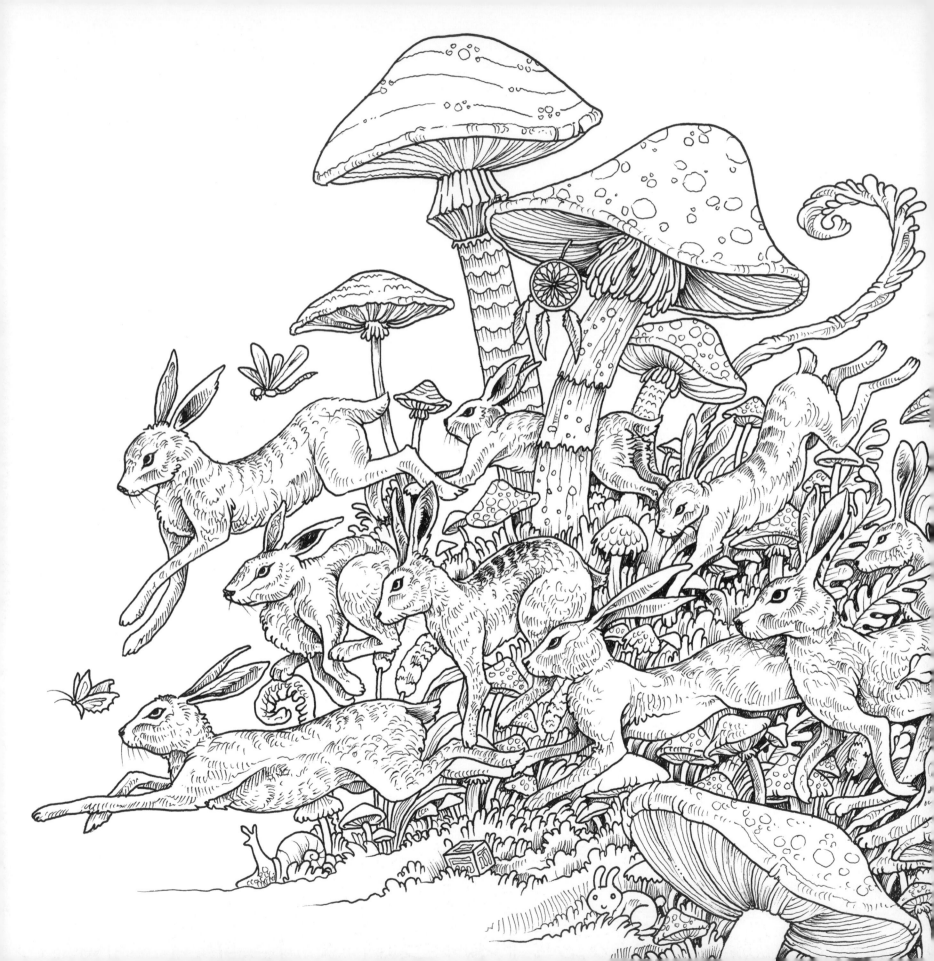

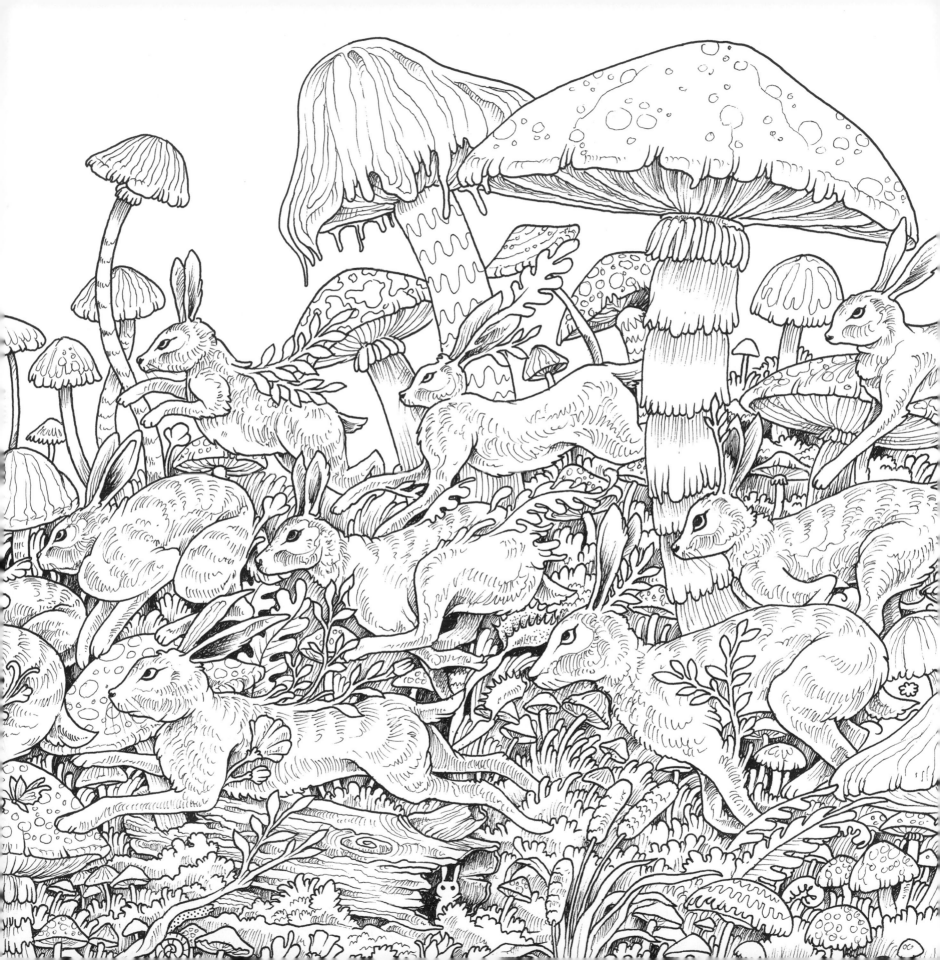

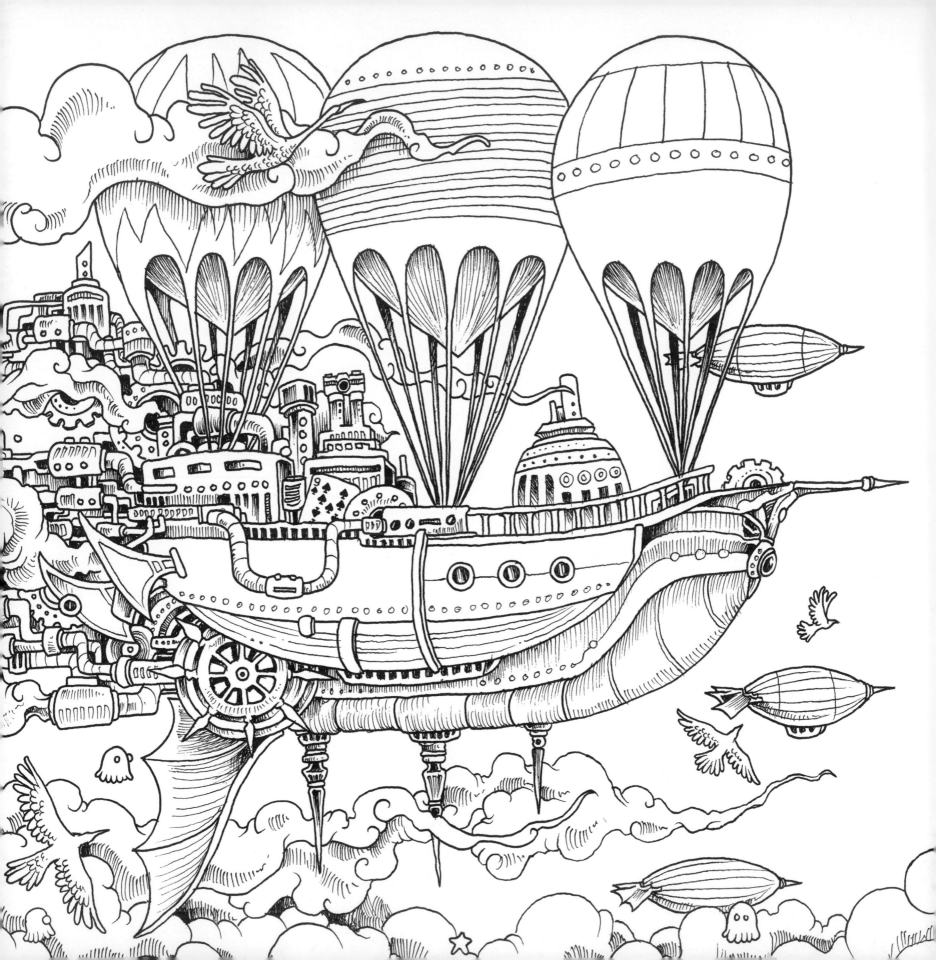

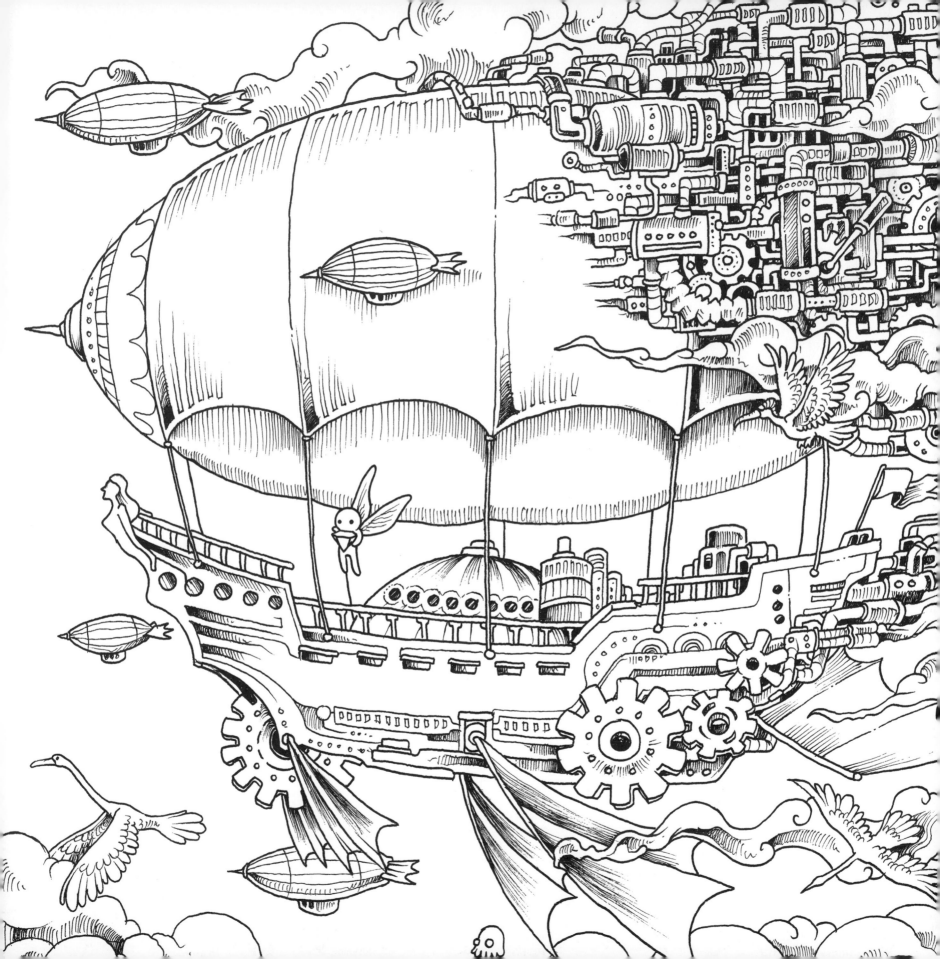

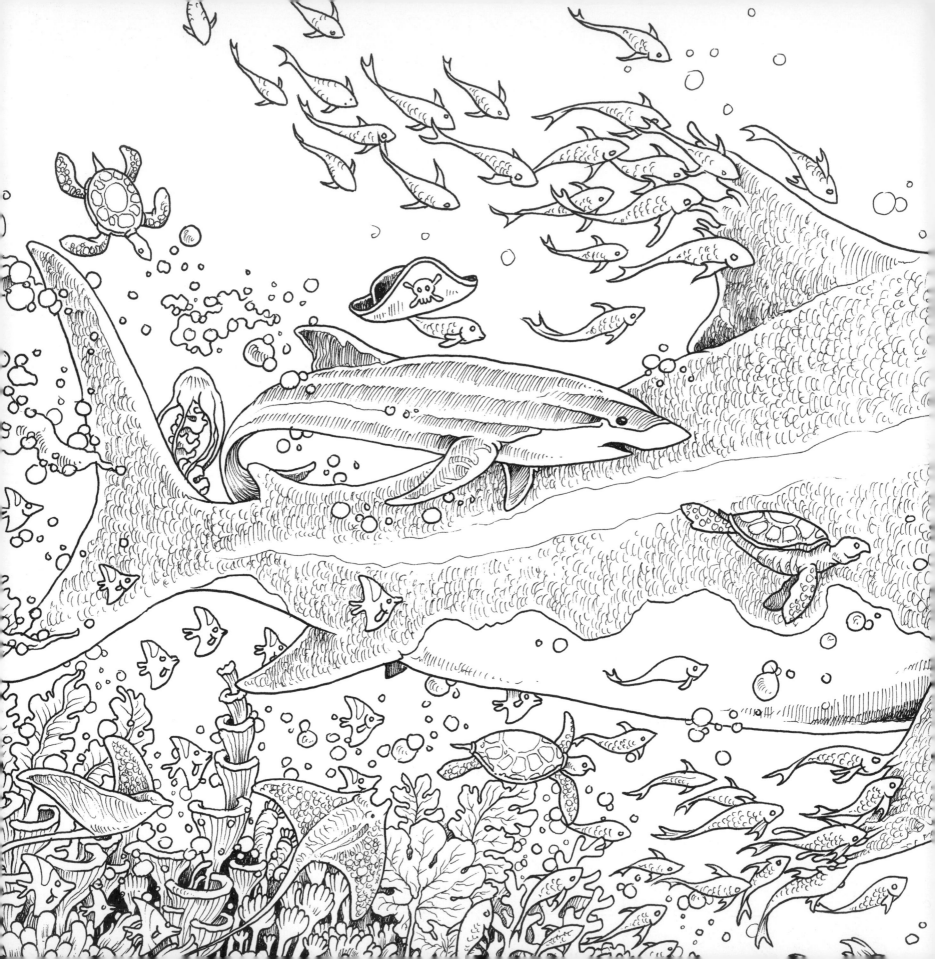

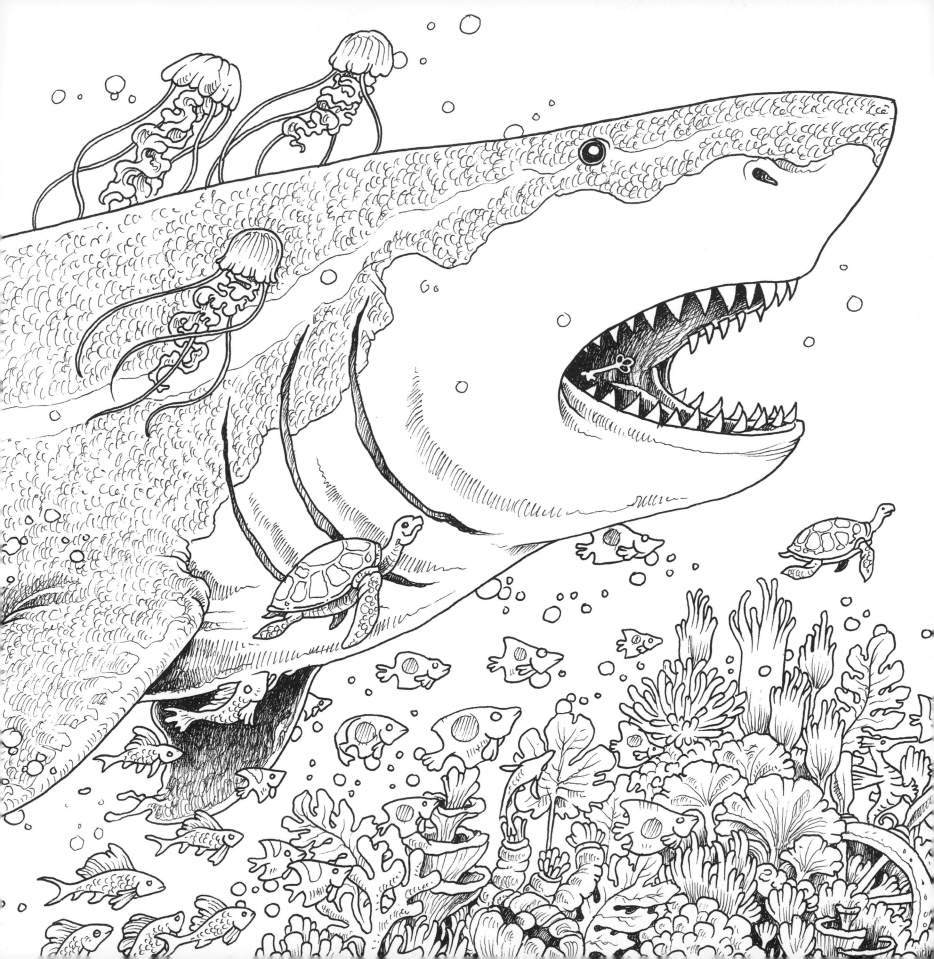

Fill the stripes with intricate patterns.

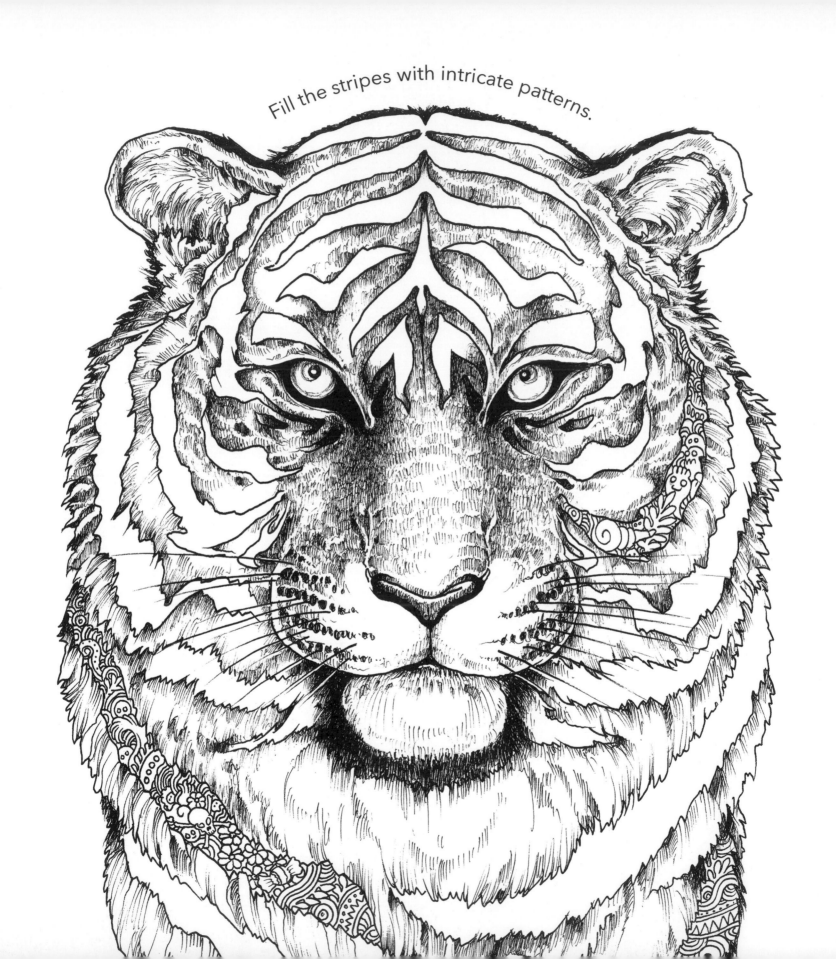

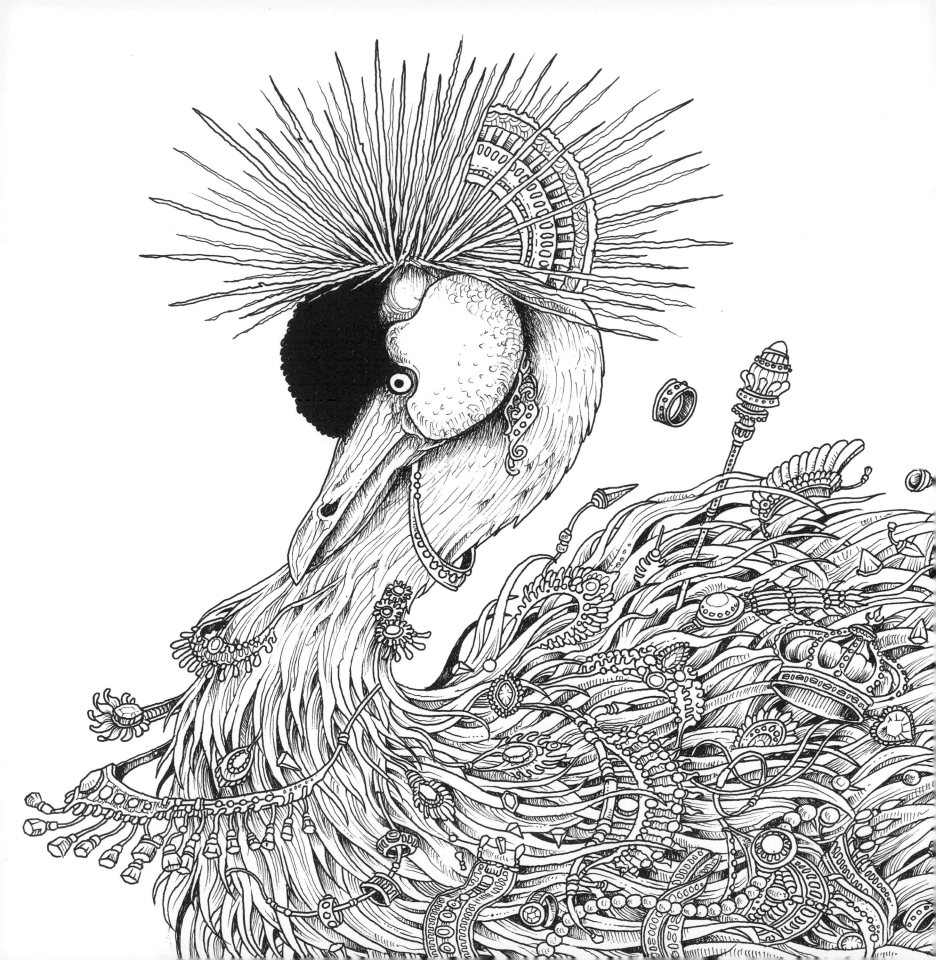

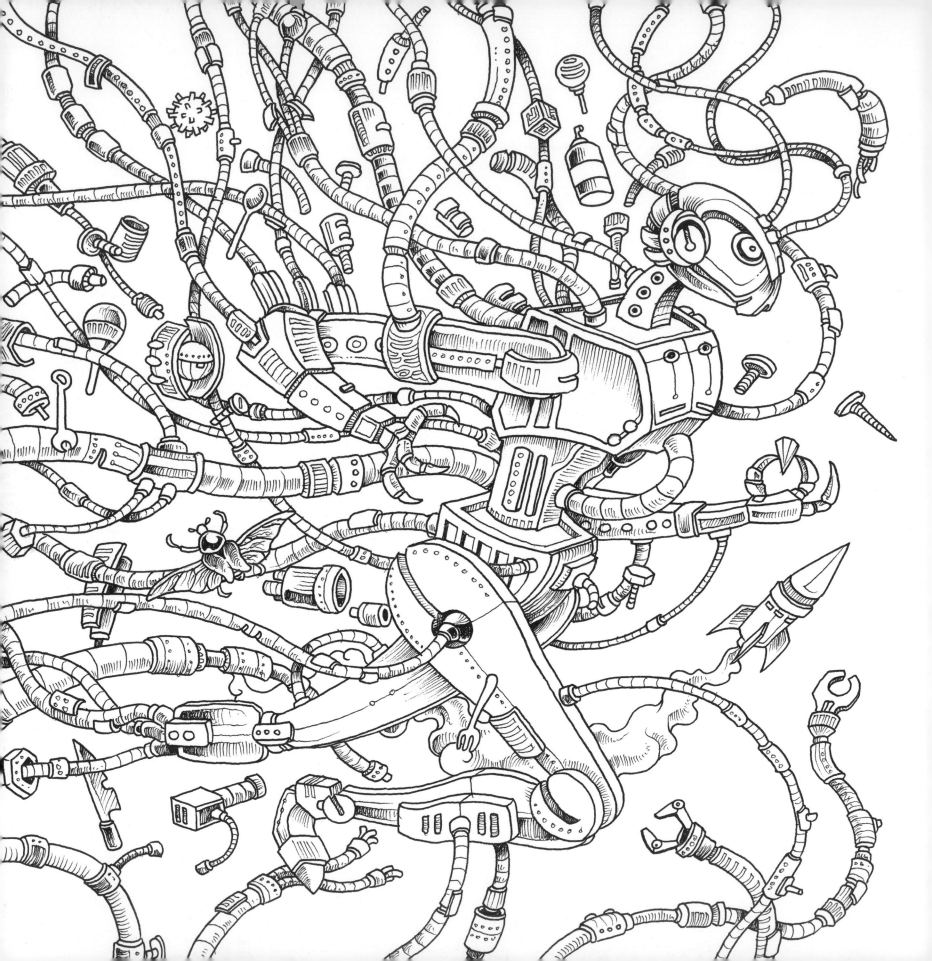

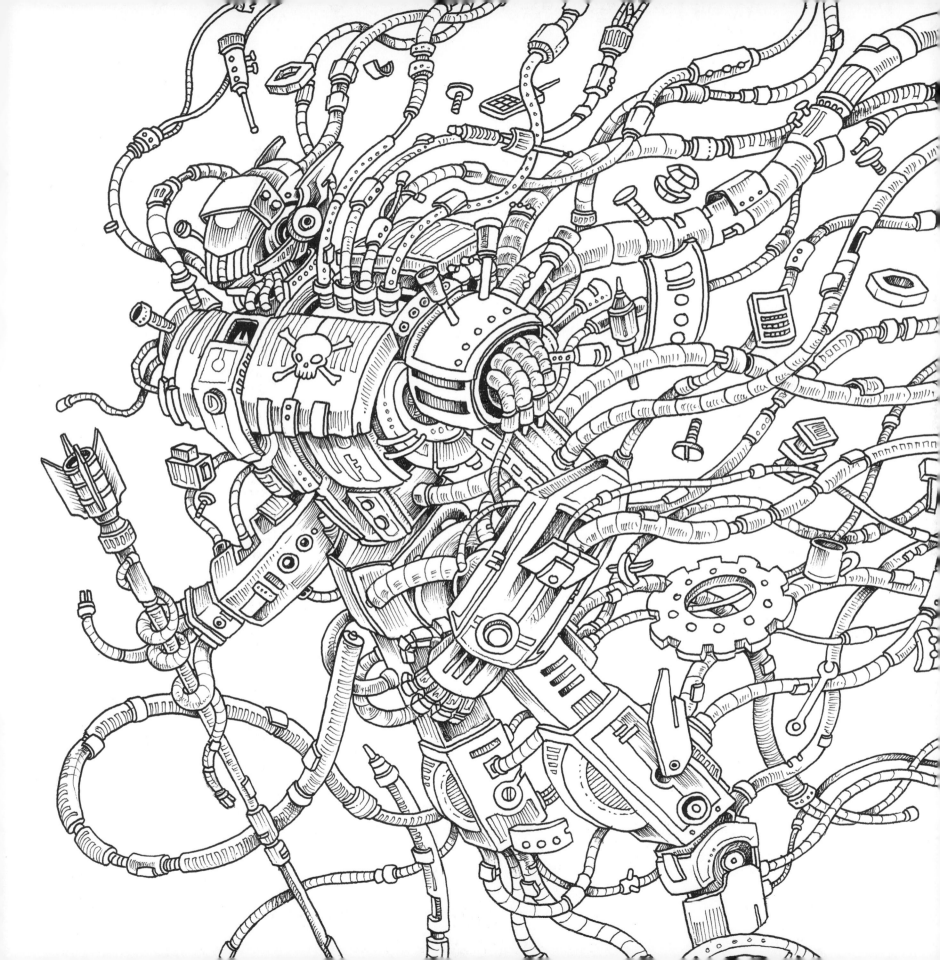

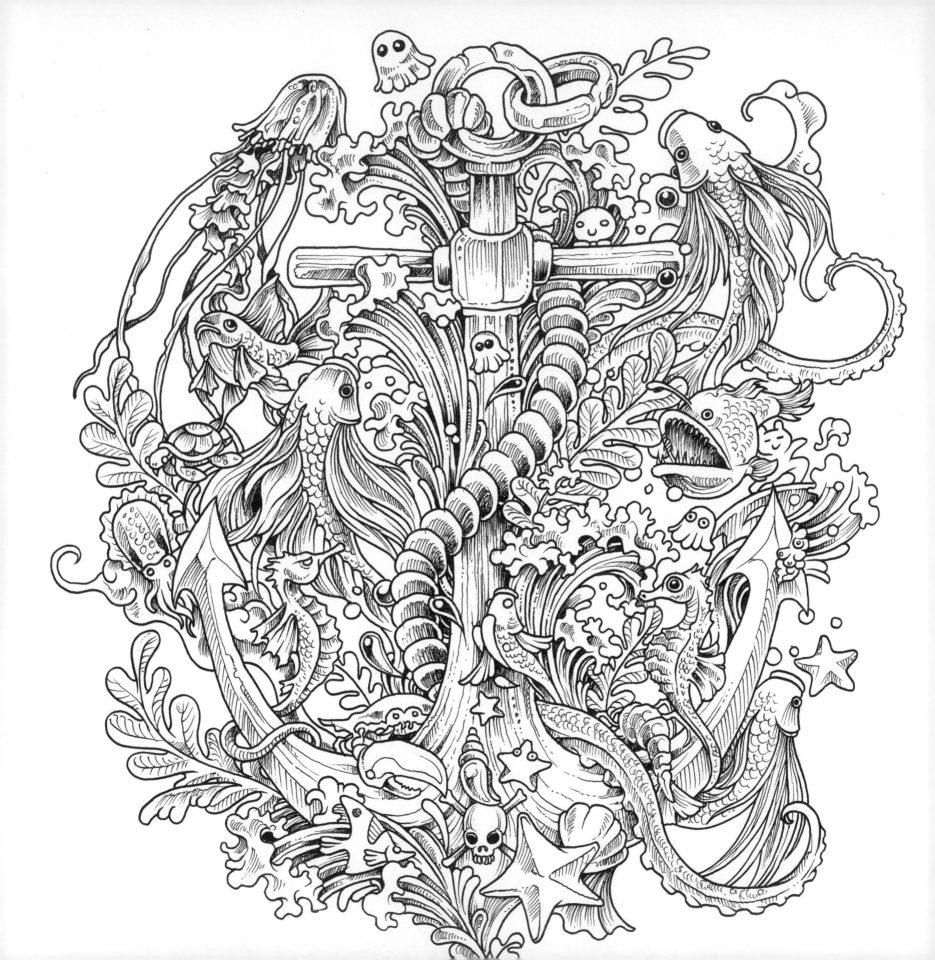

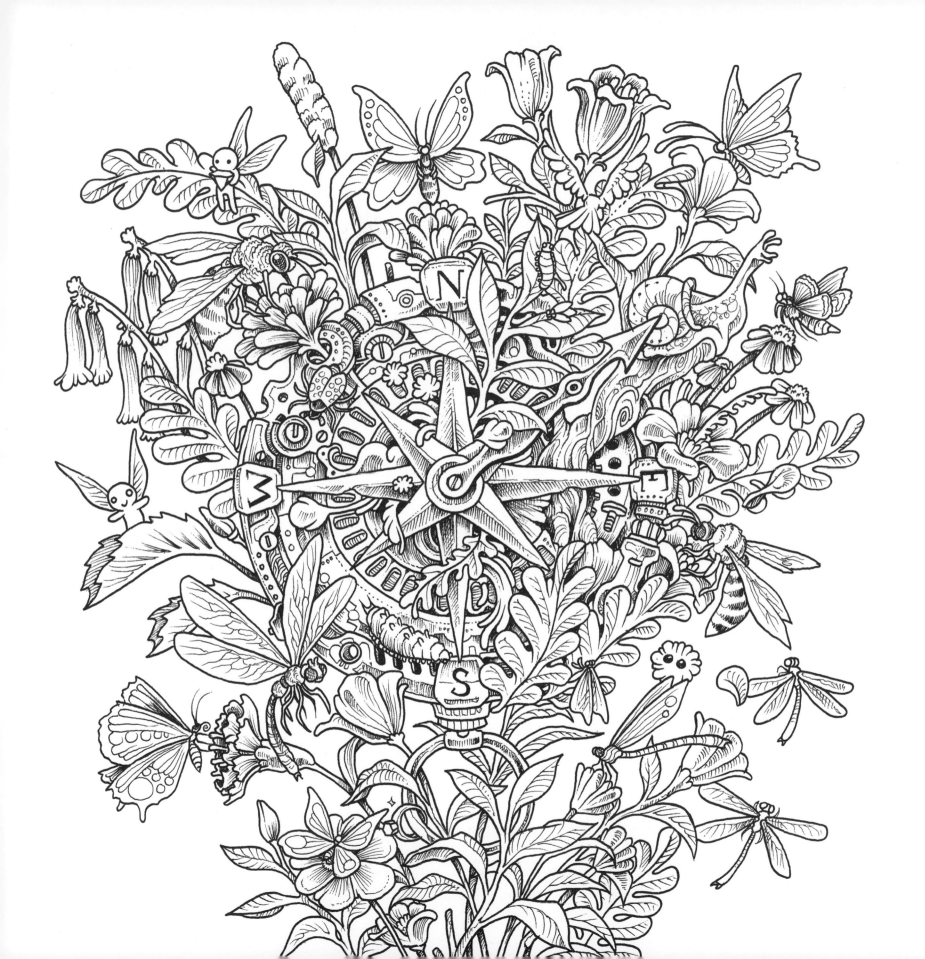

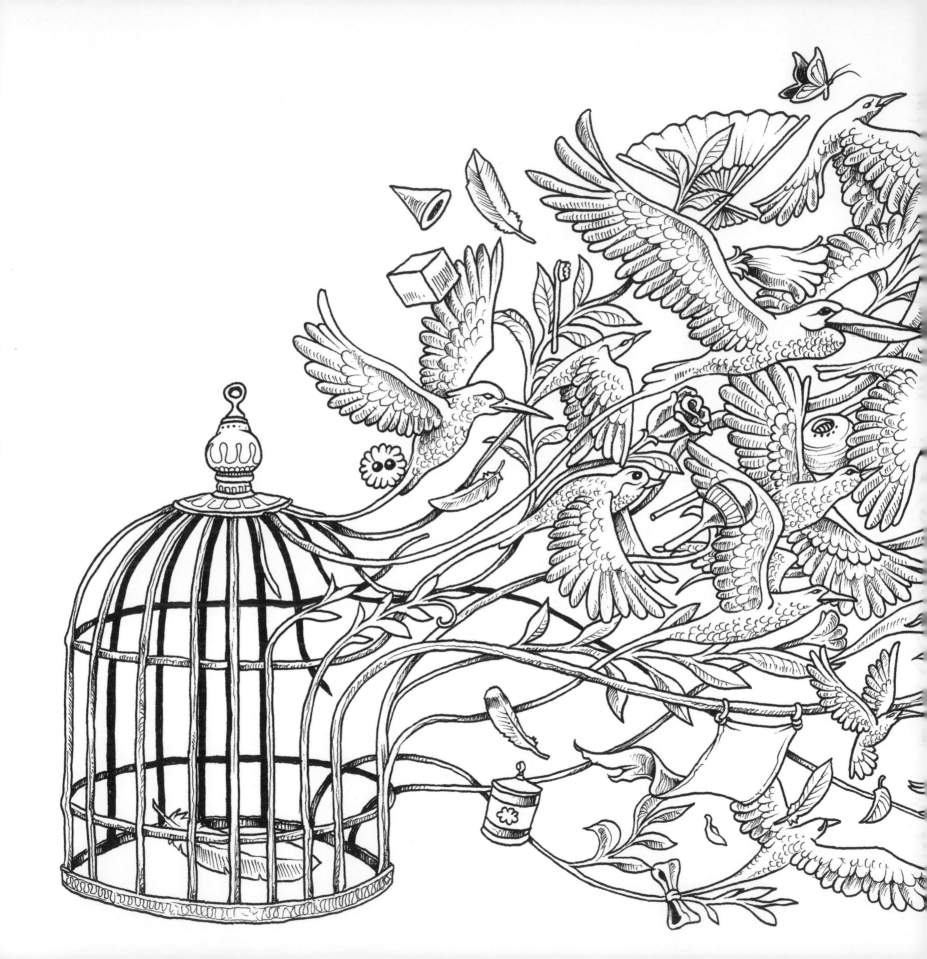

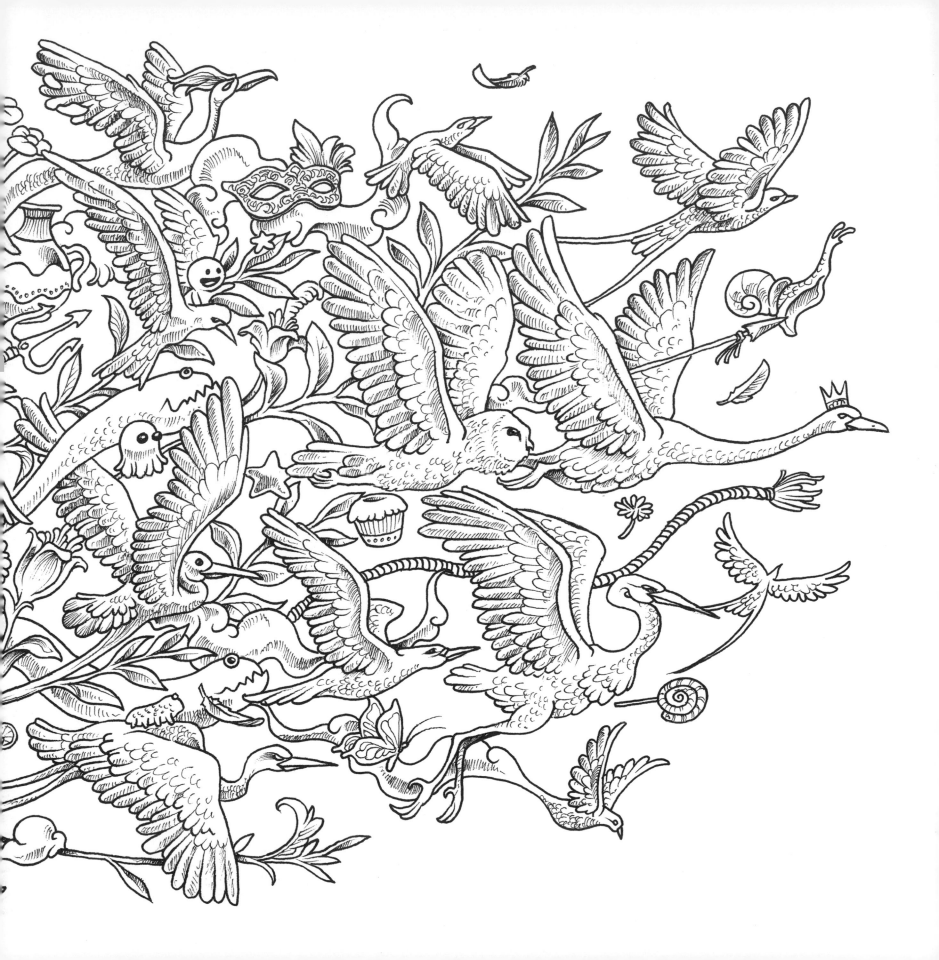

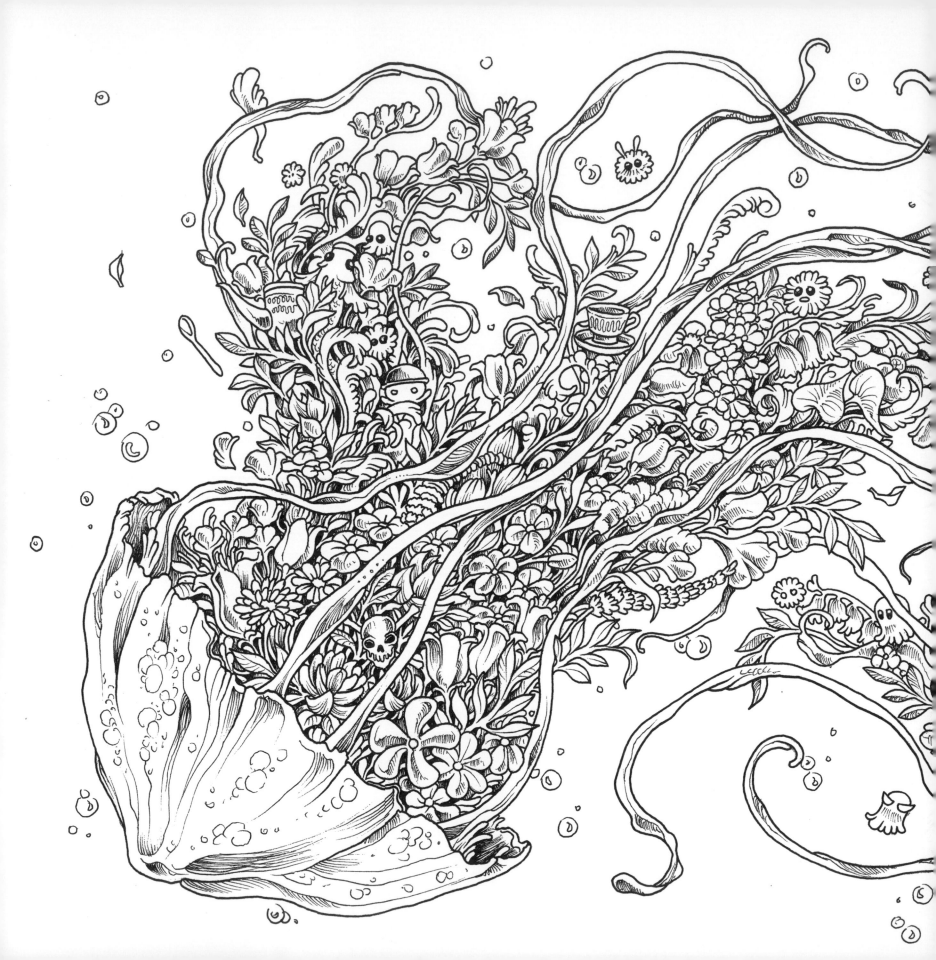

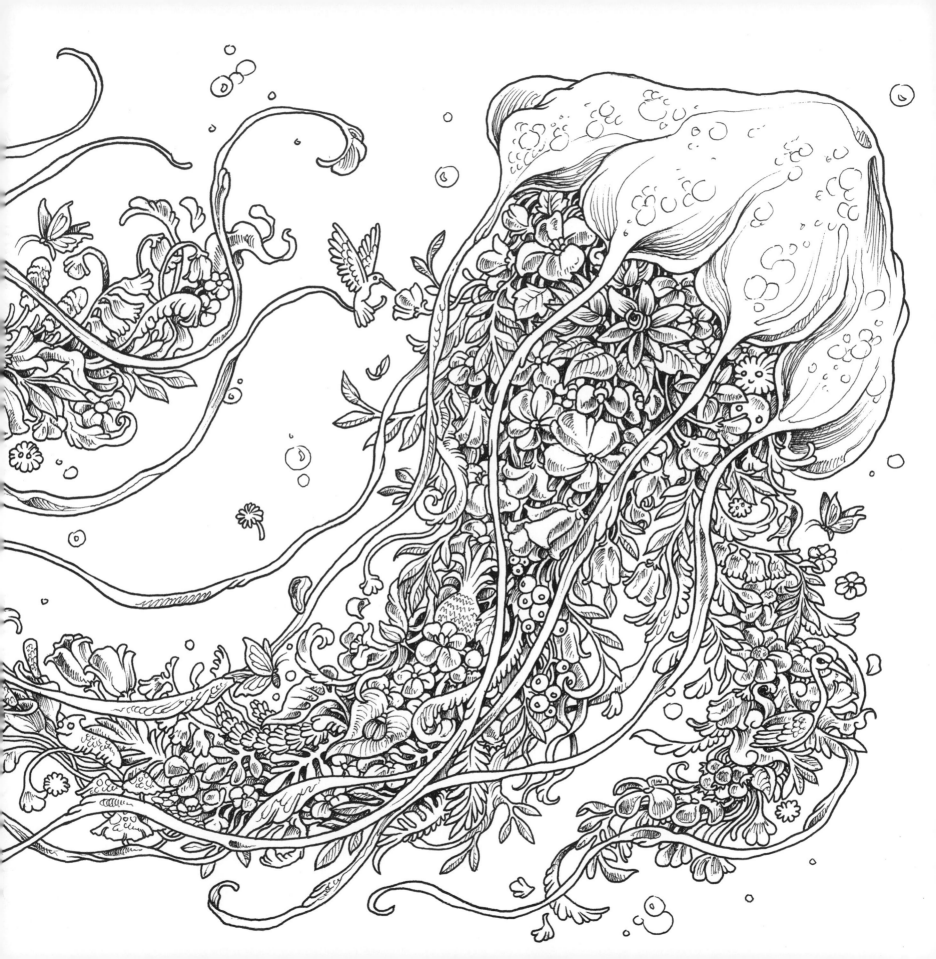

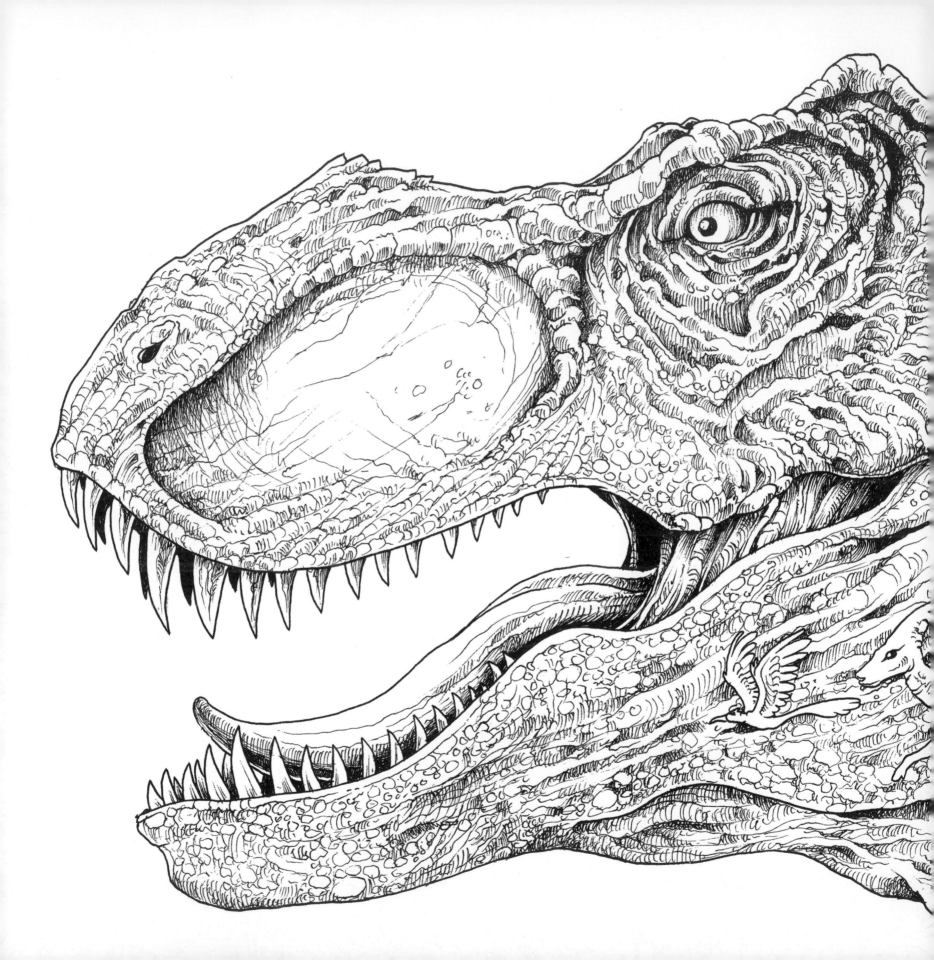

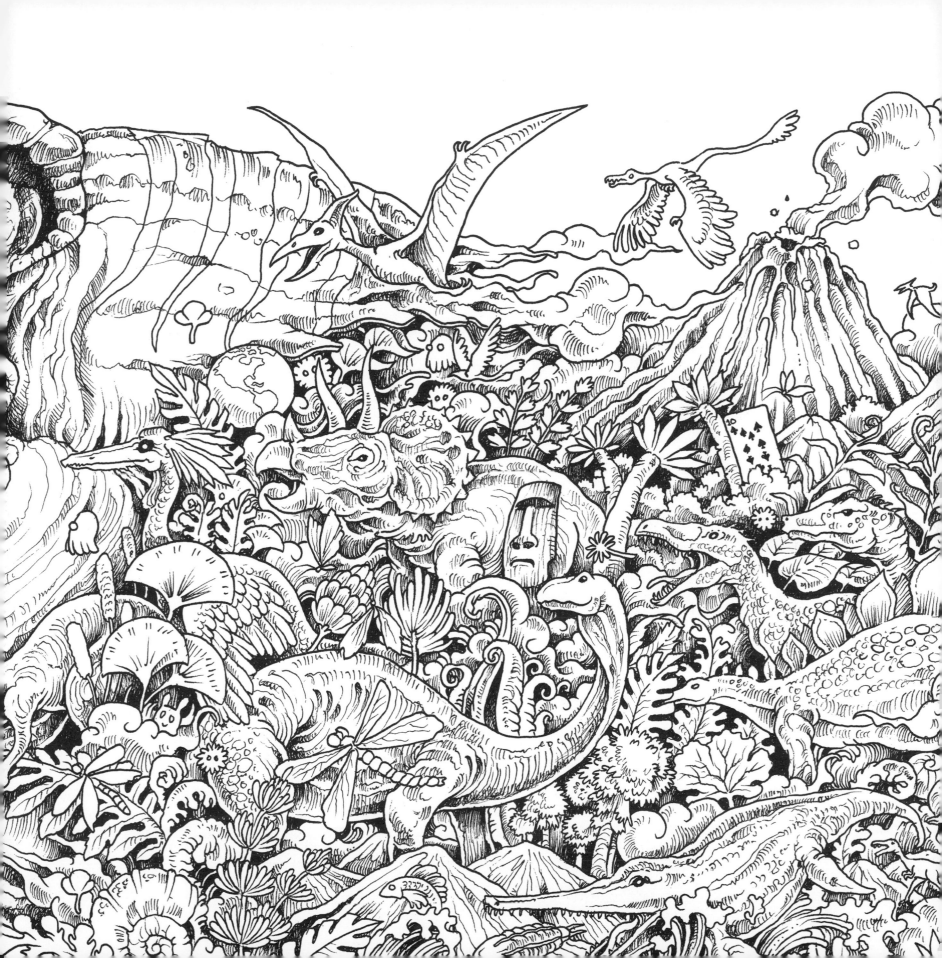

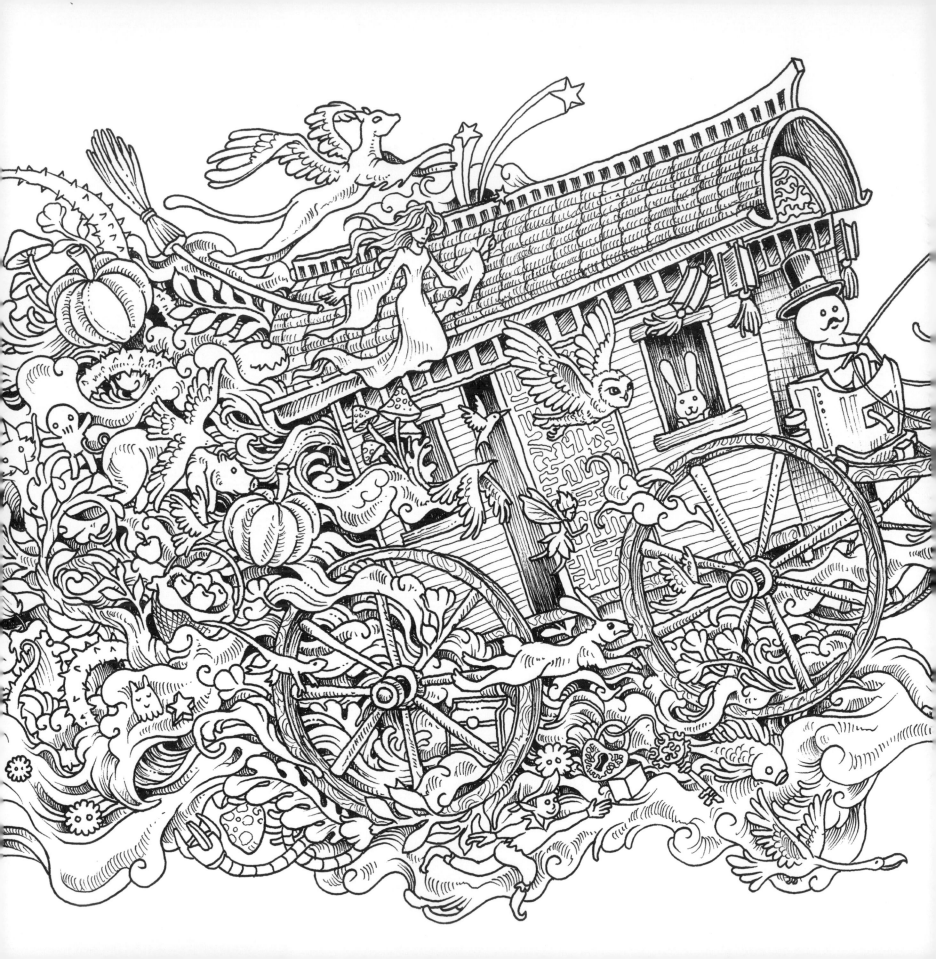

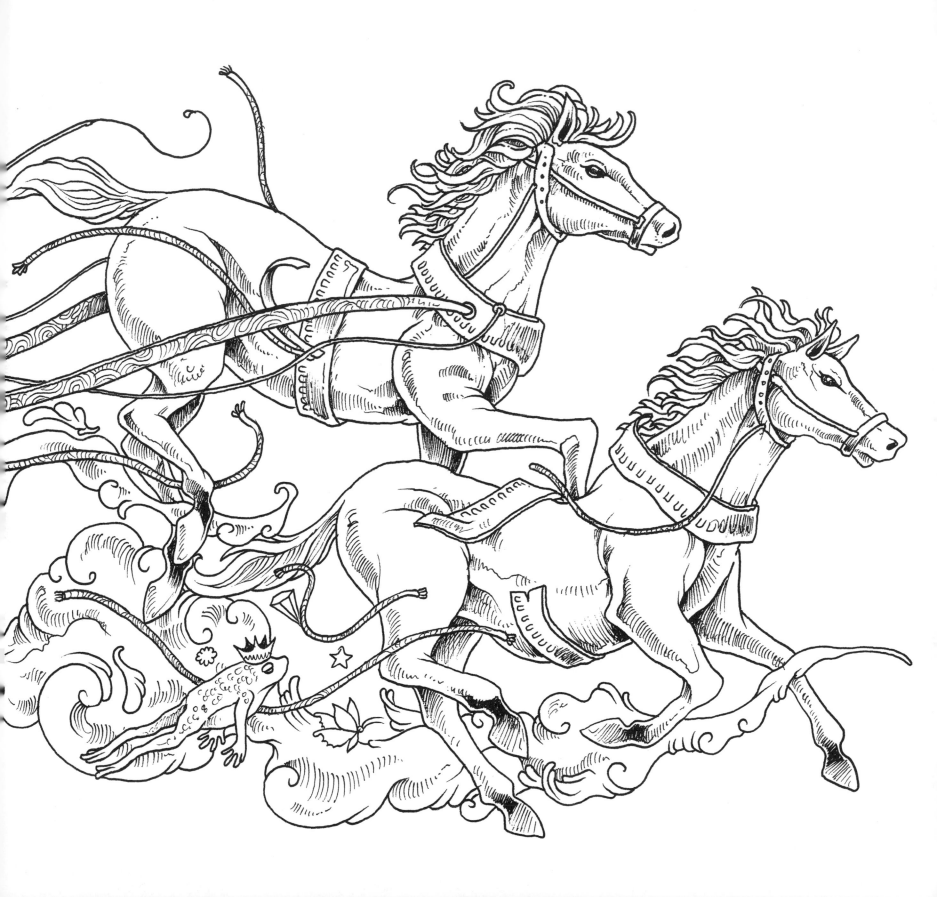

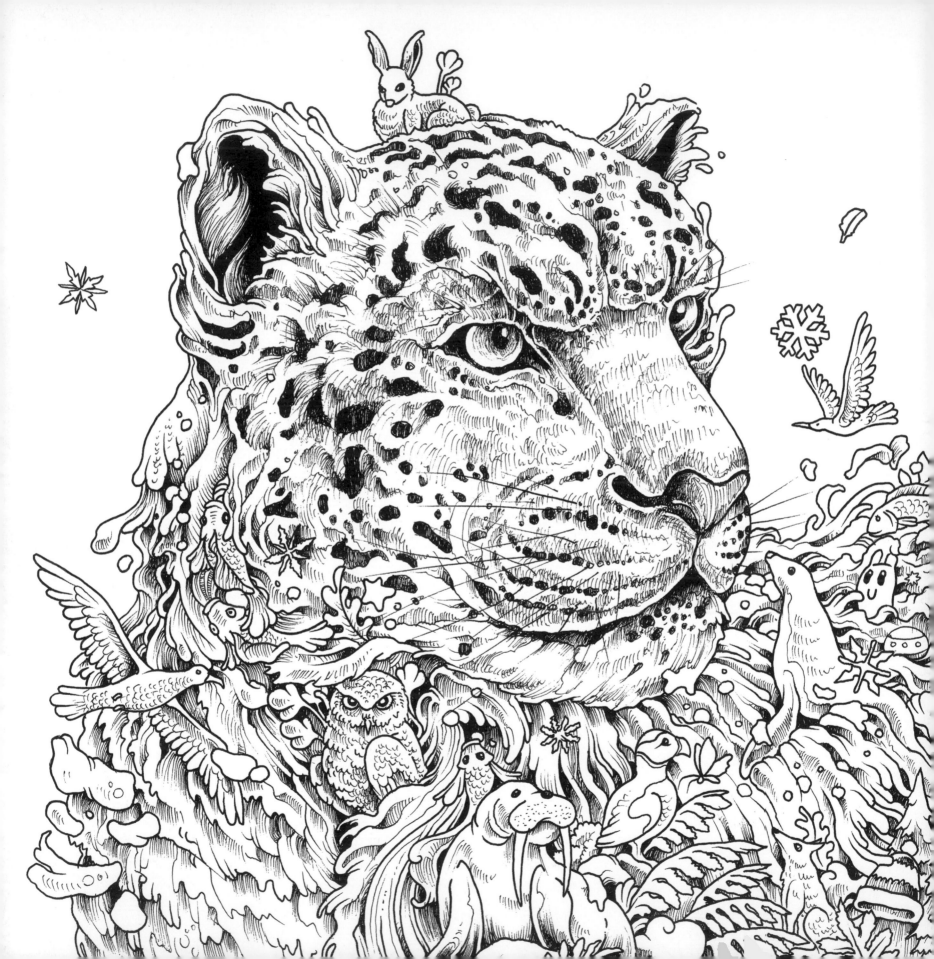

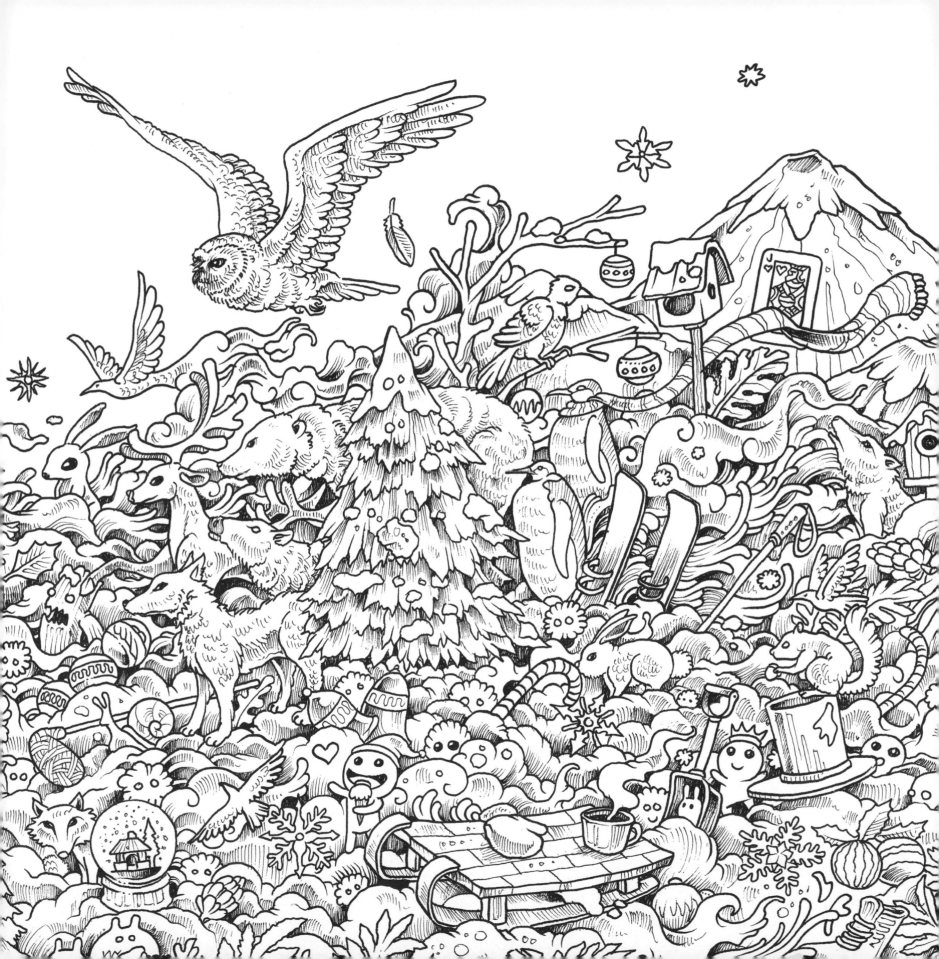

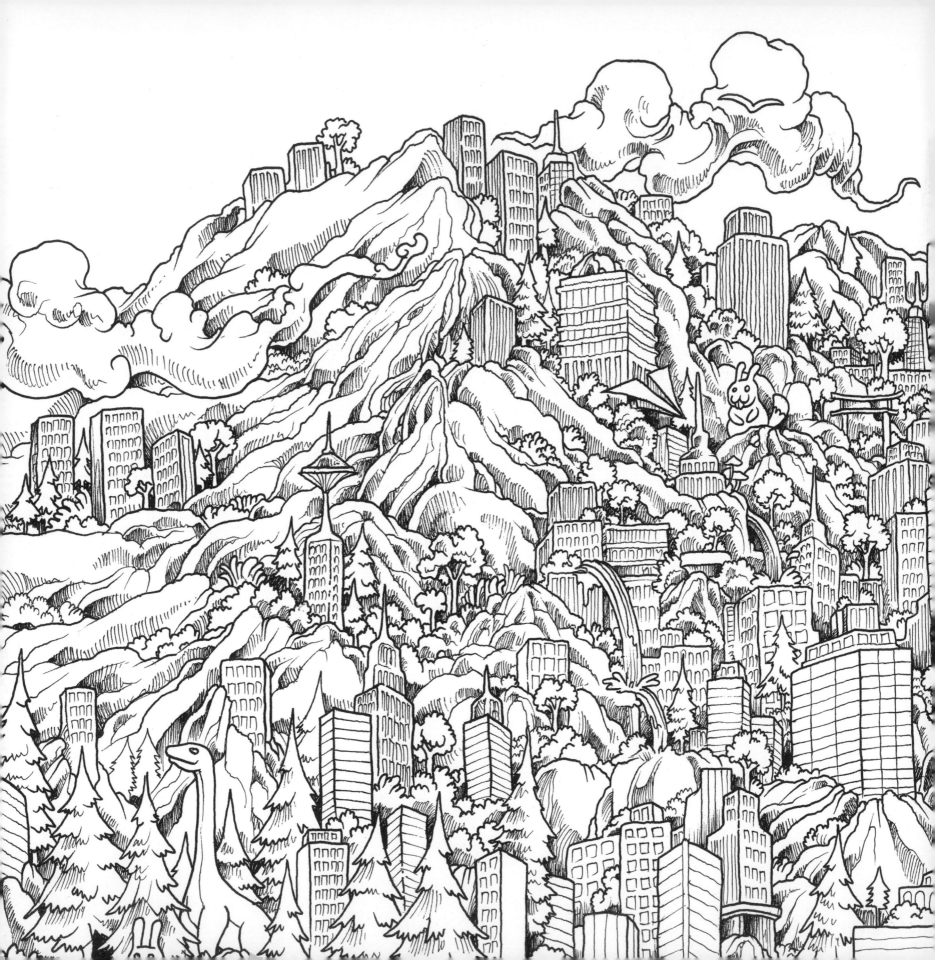

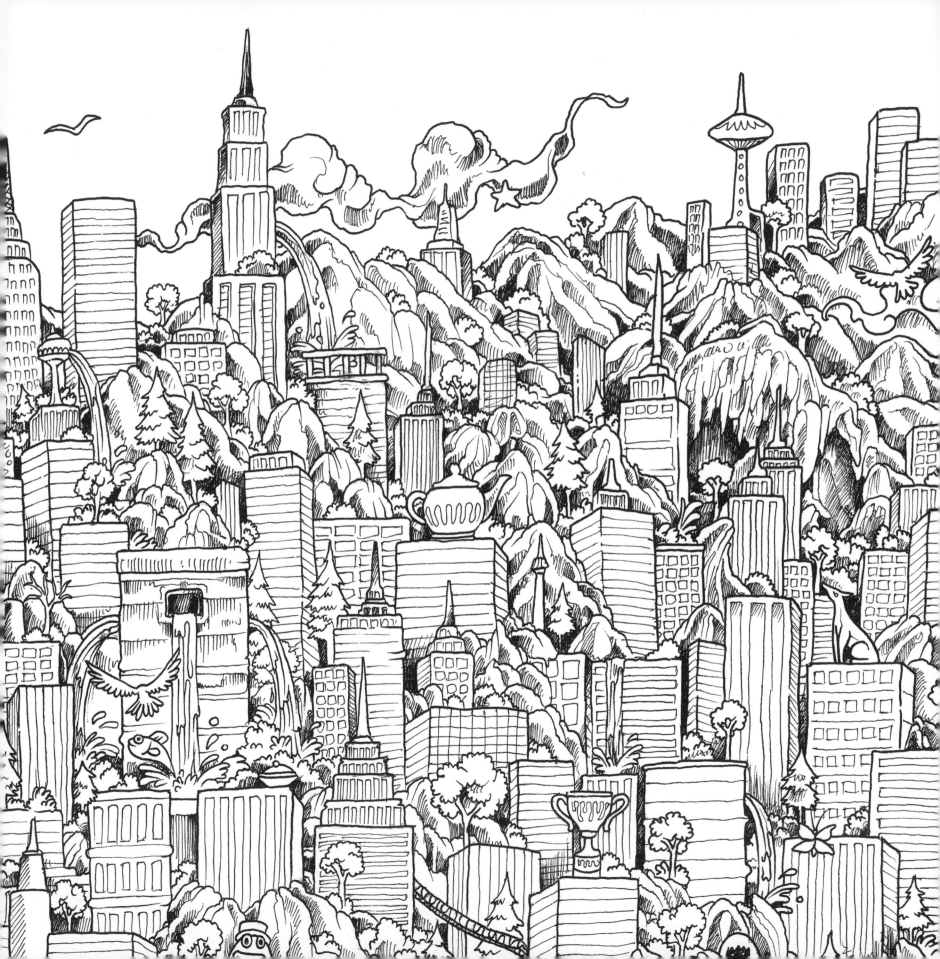

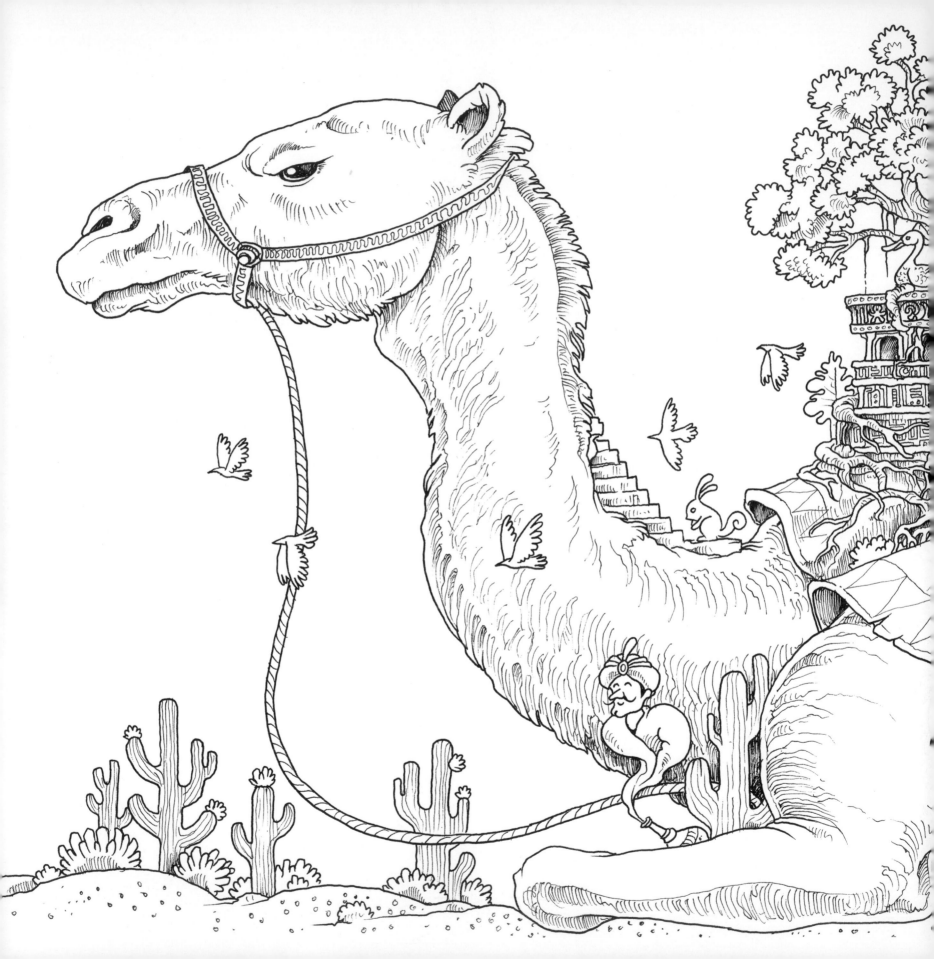

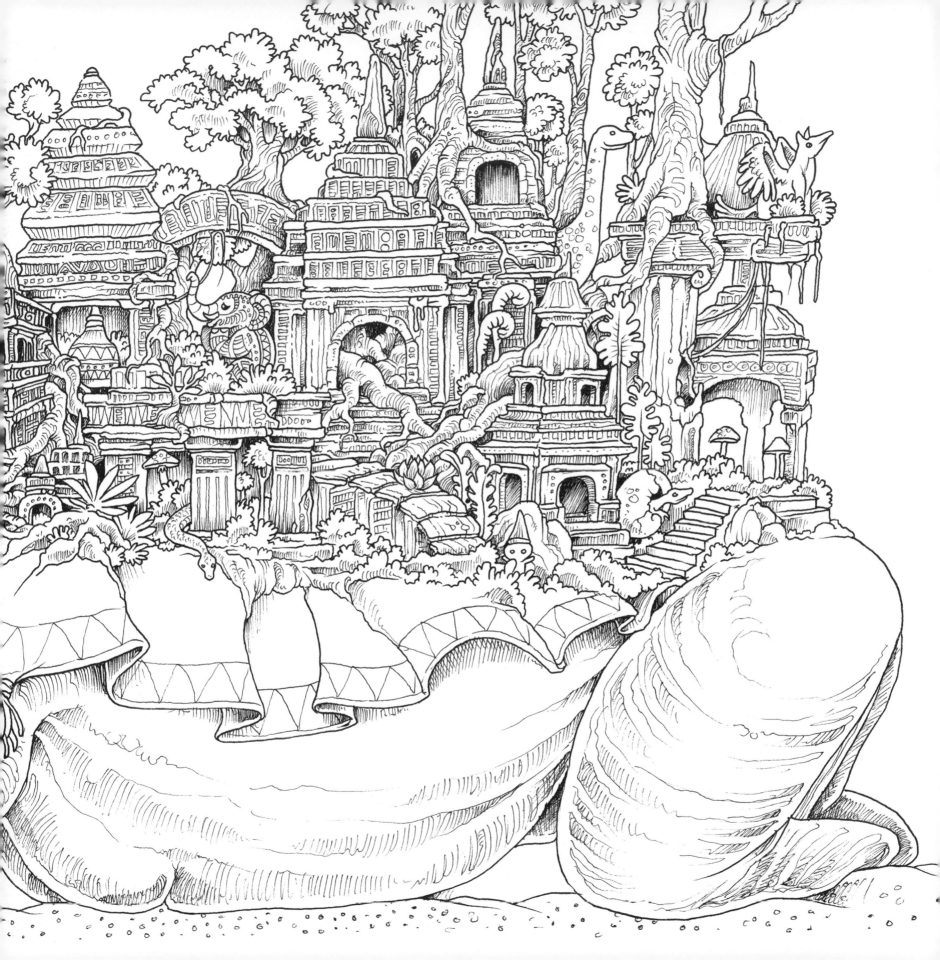

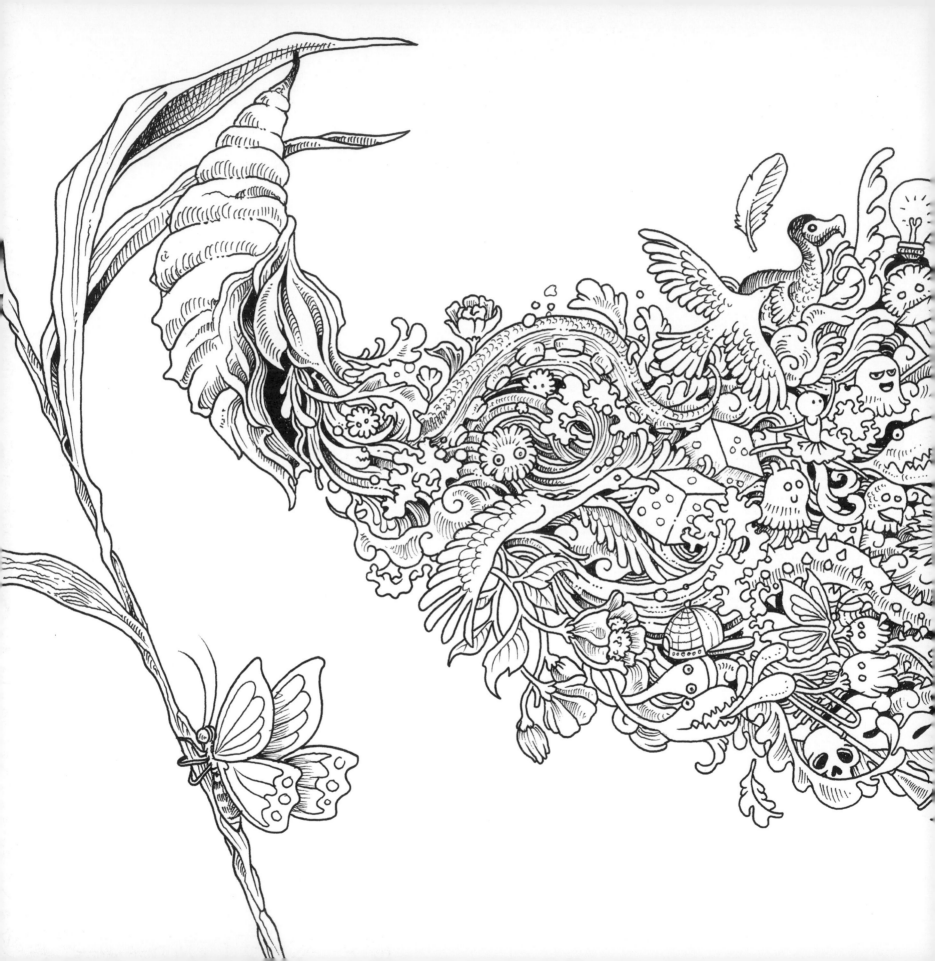

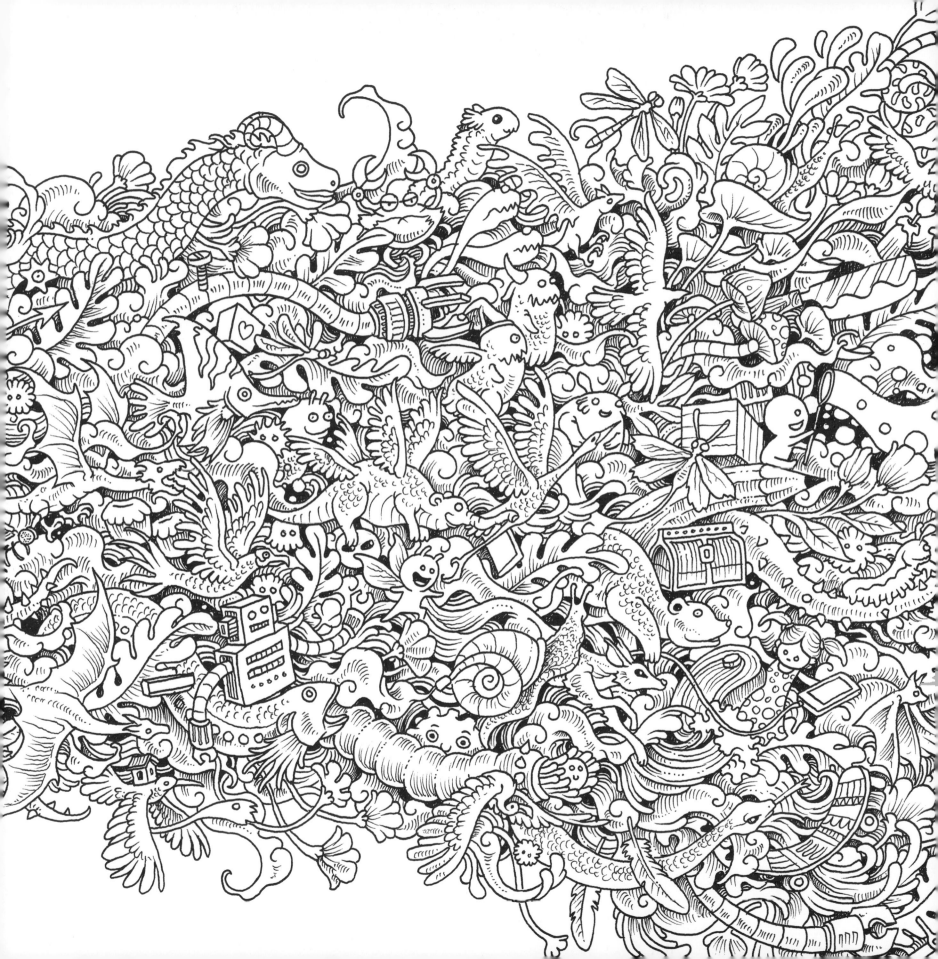

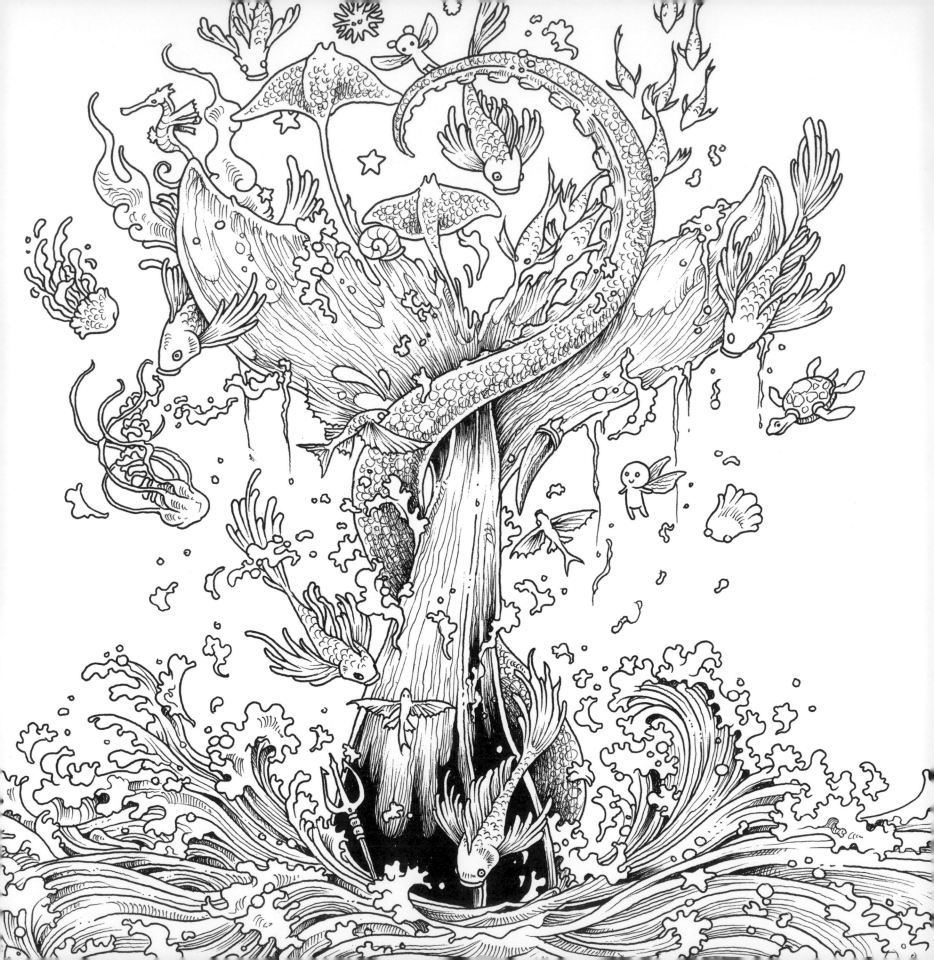

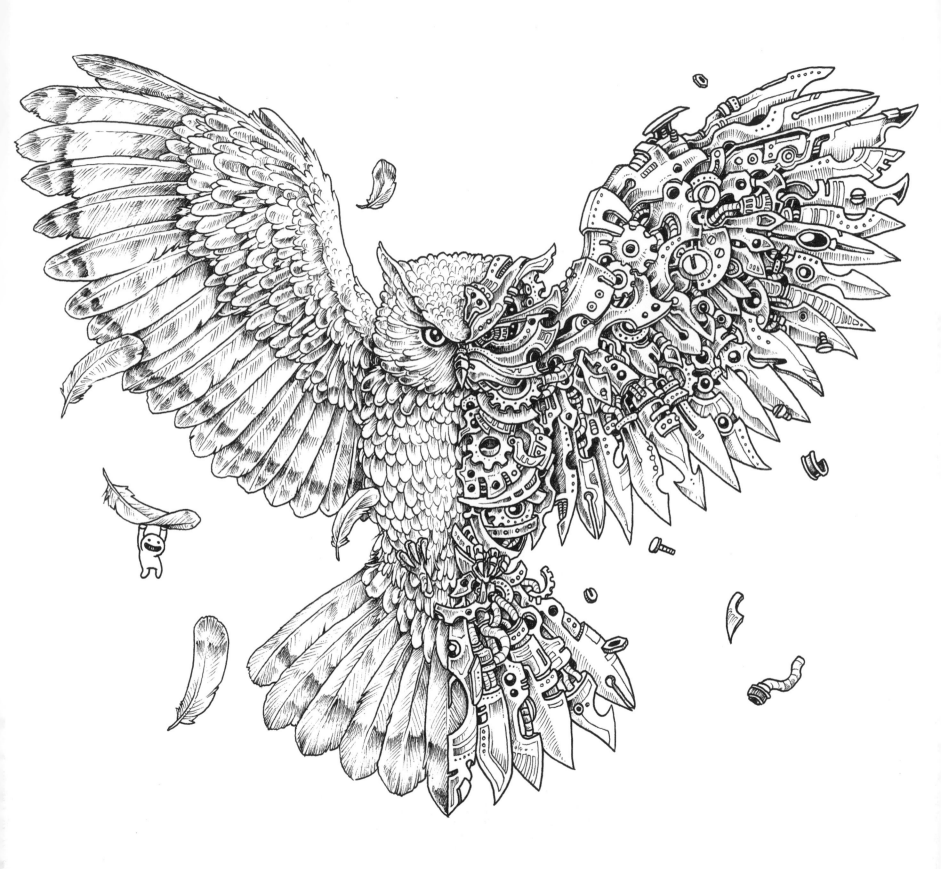

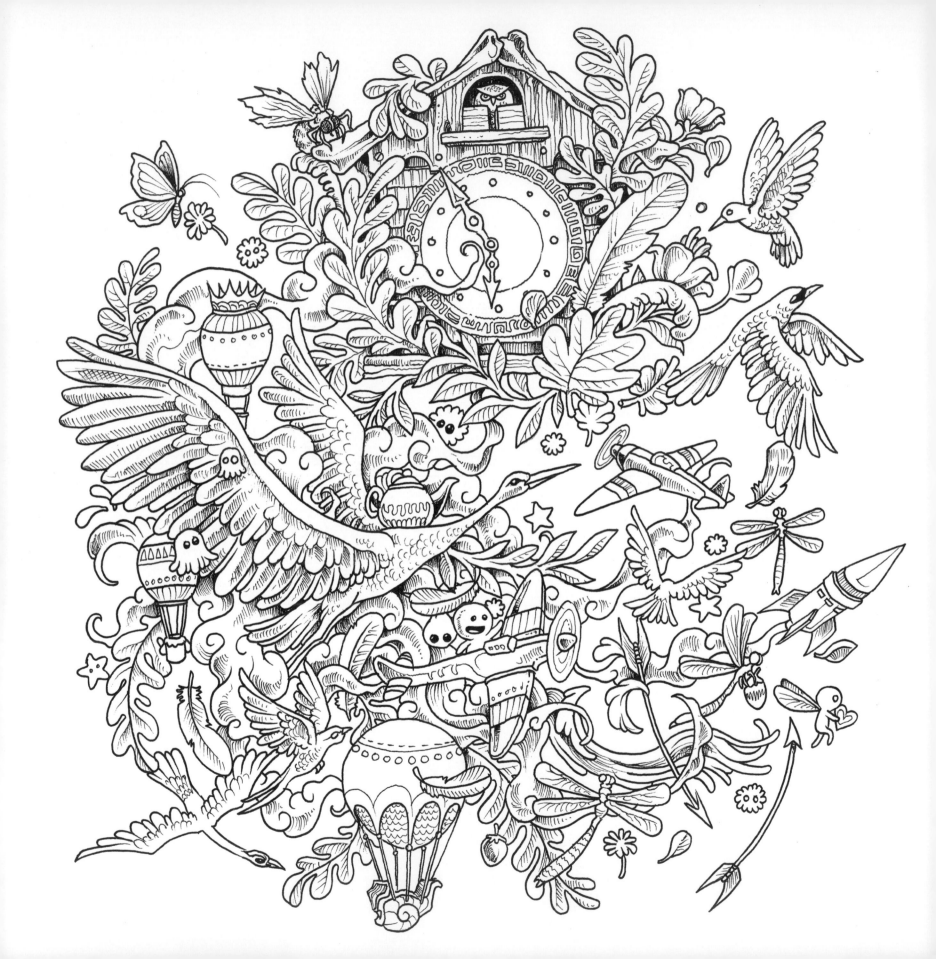

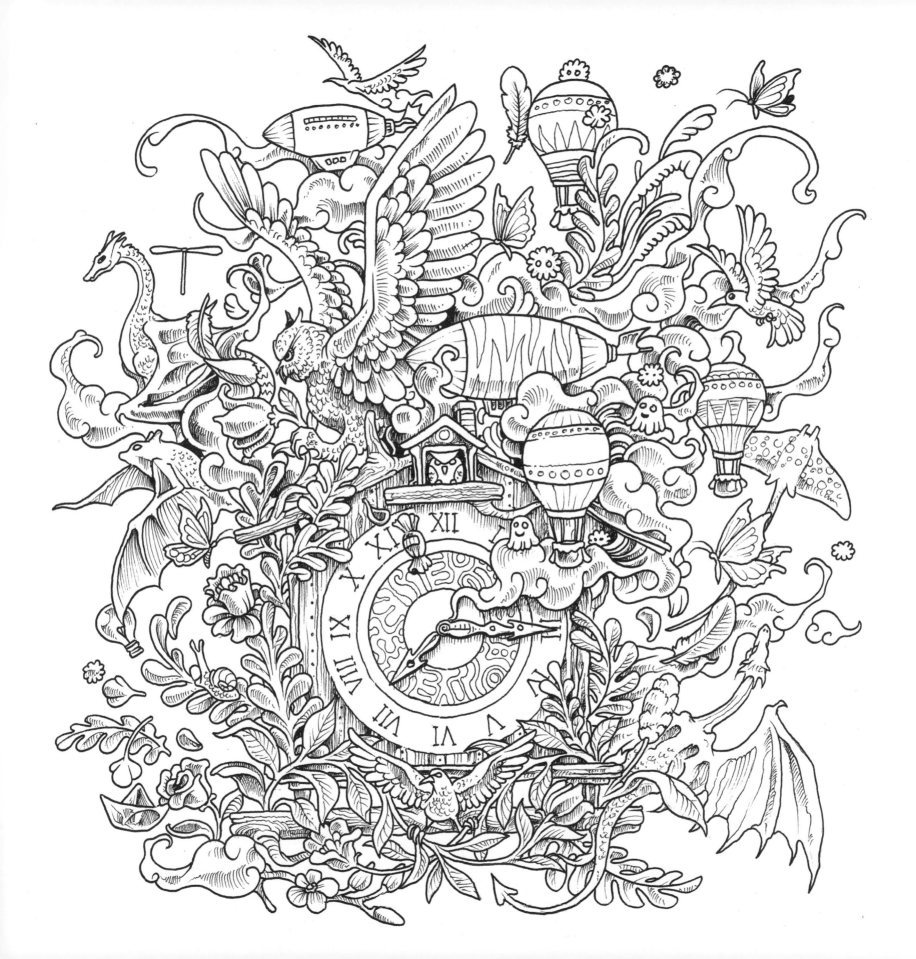

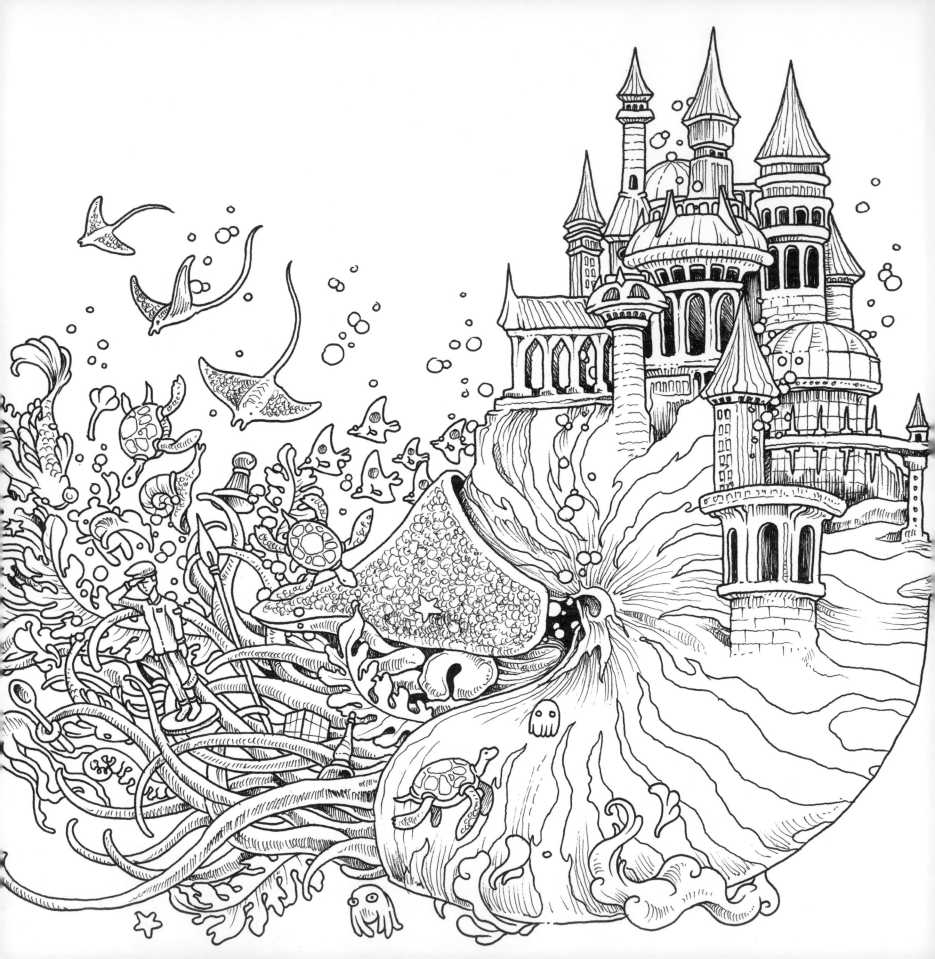

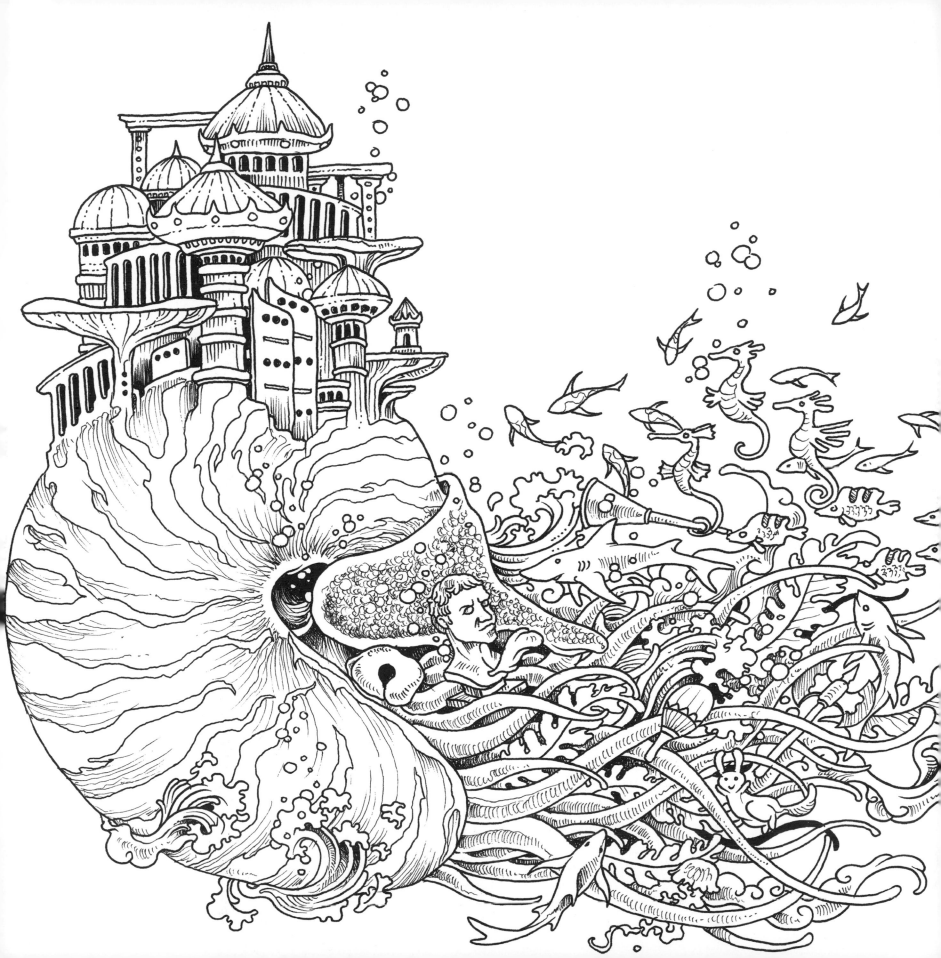

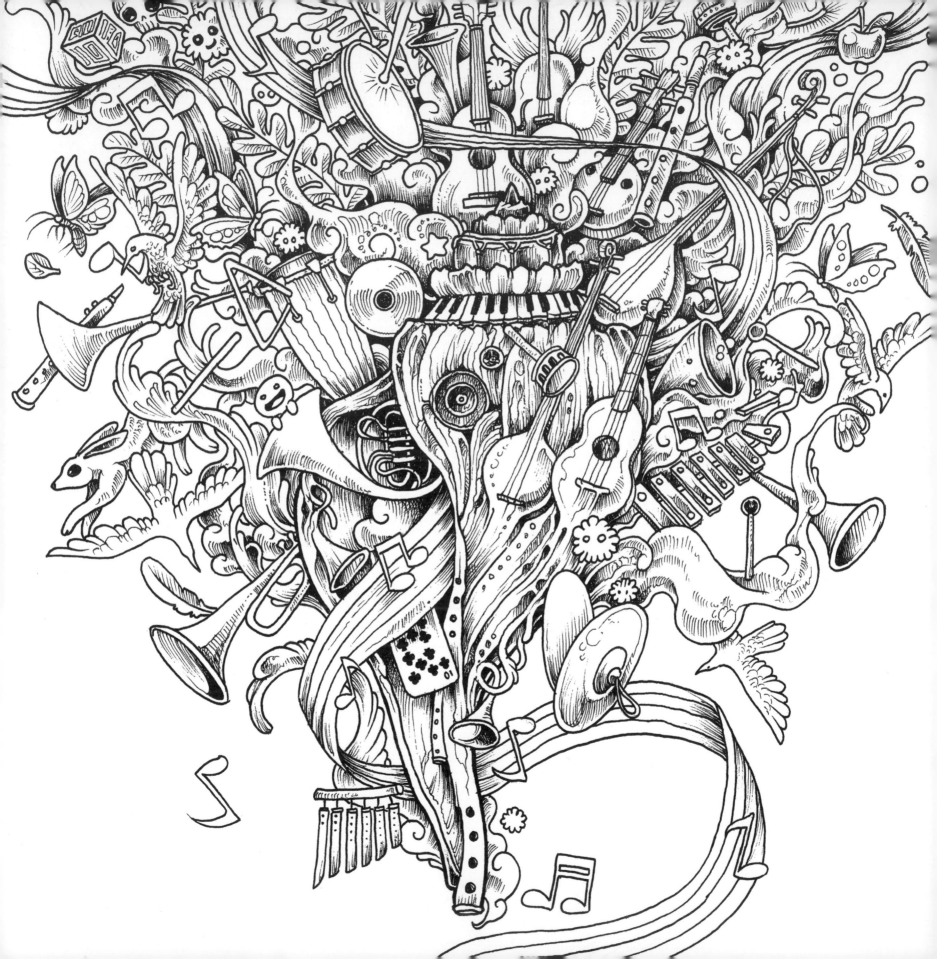

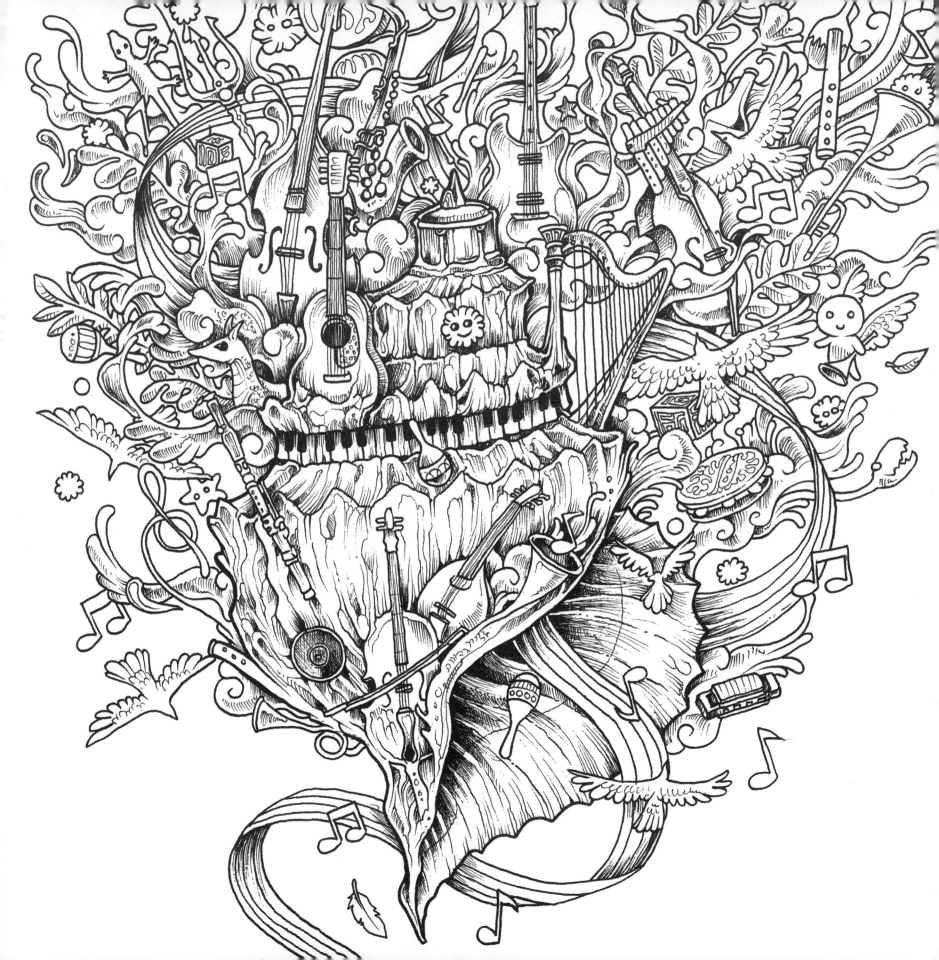

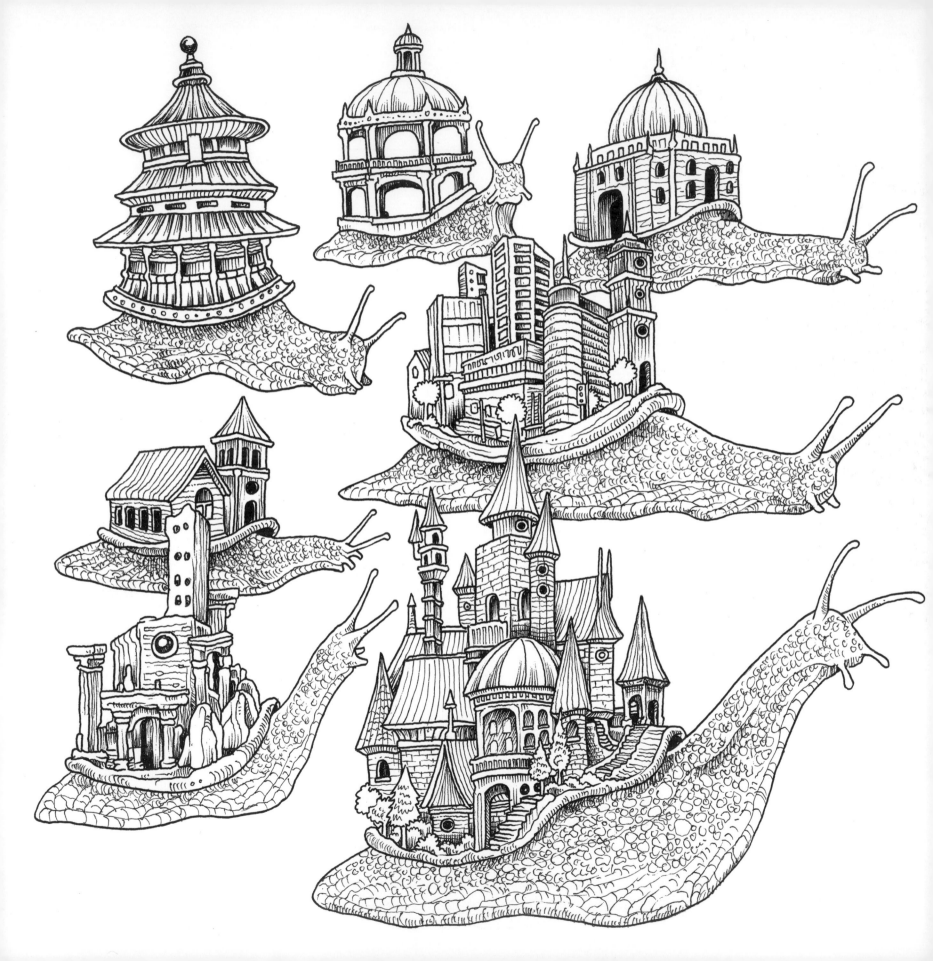

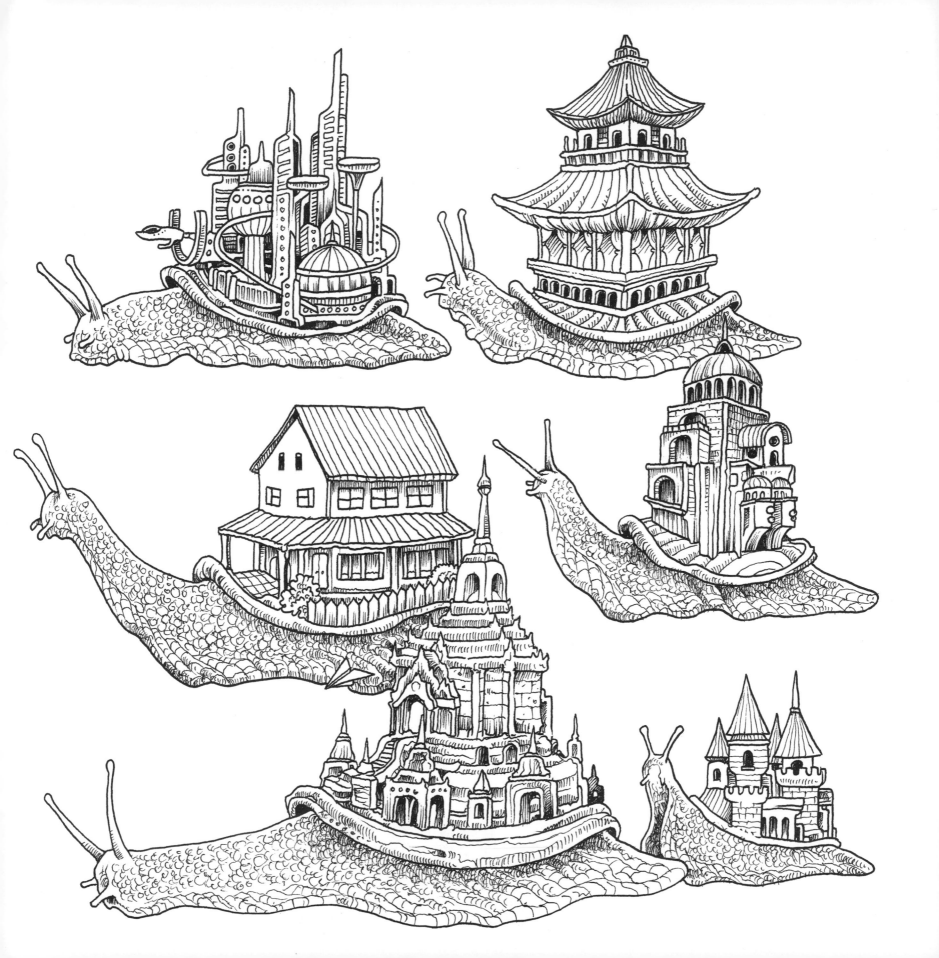

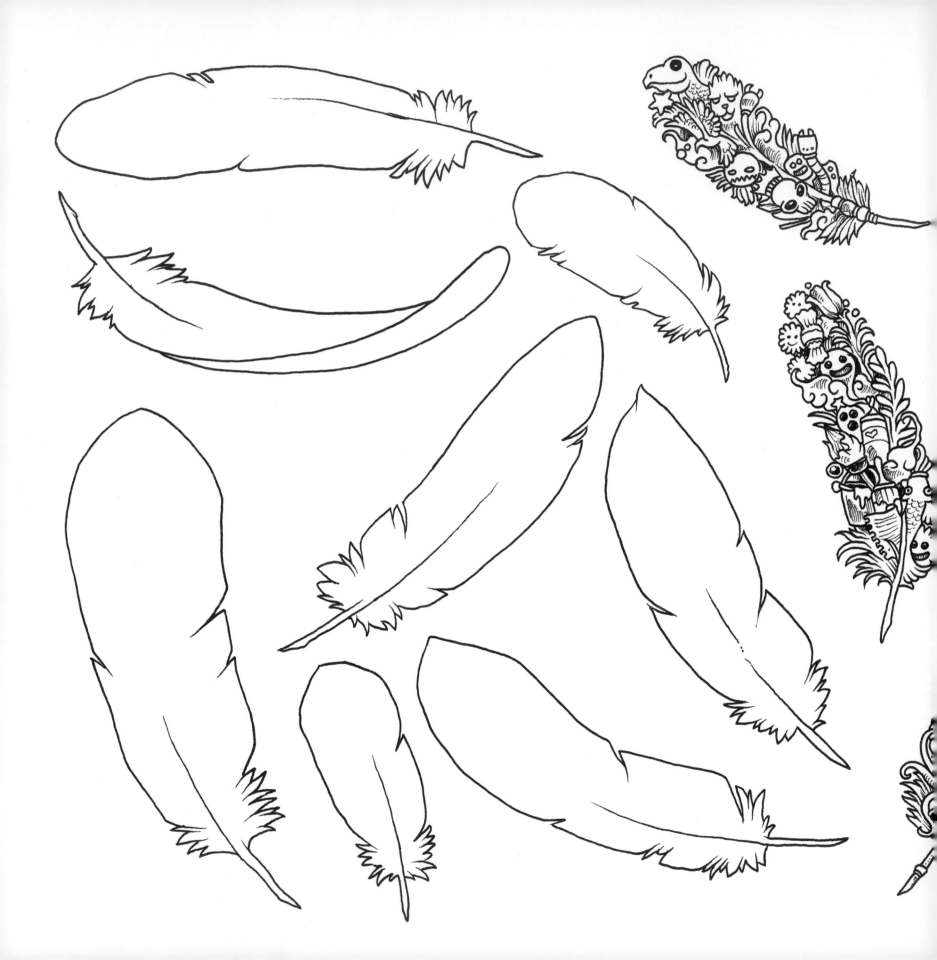

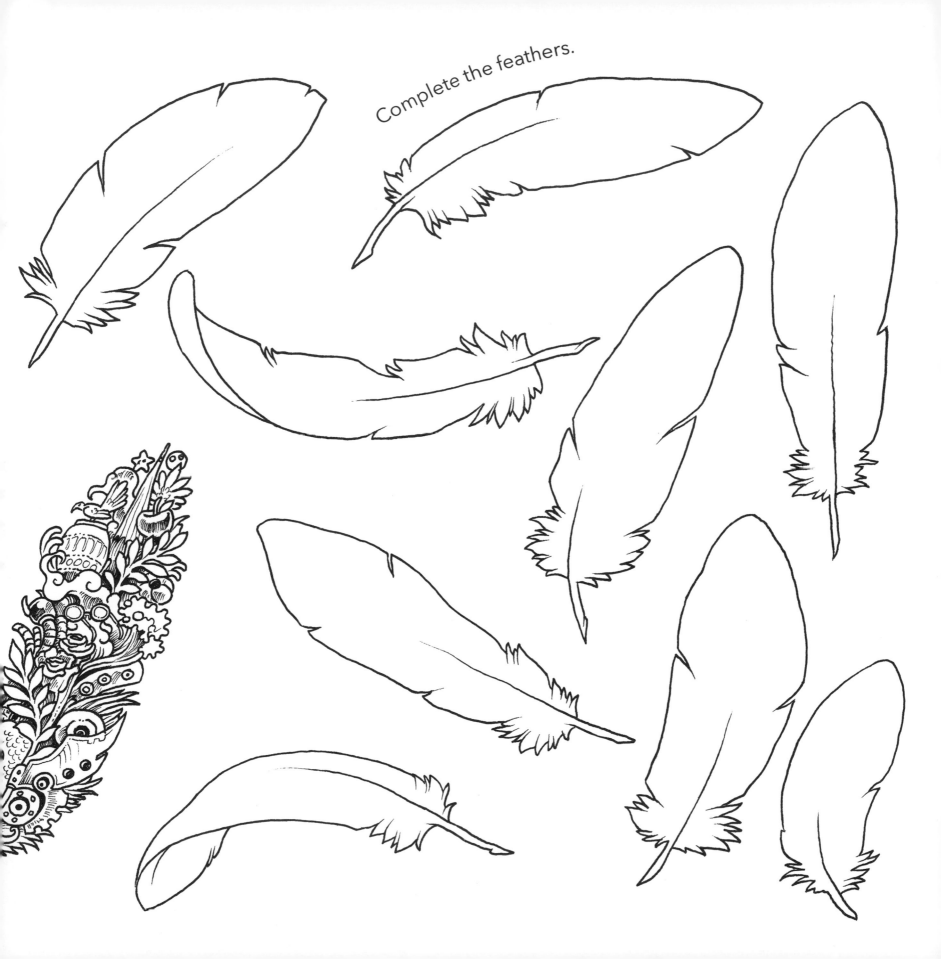

Complete the feathers.

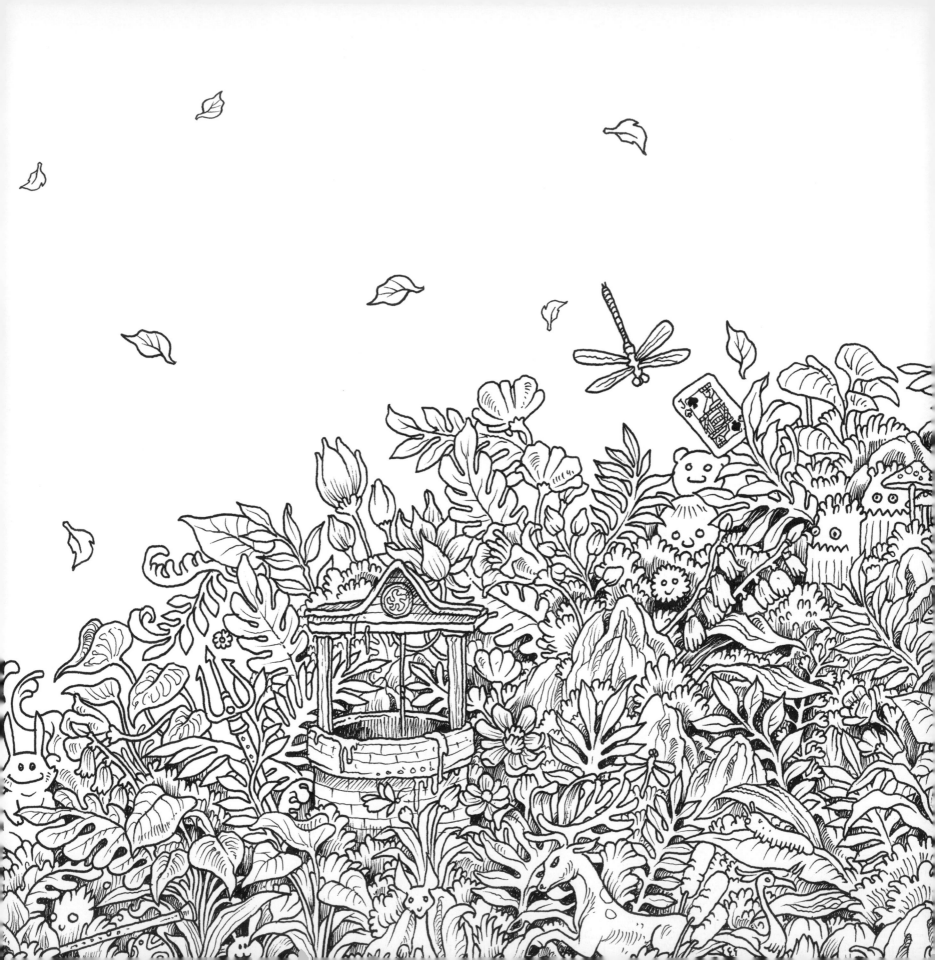

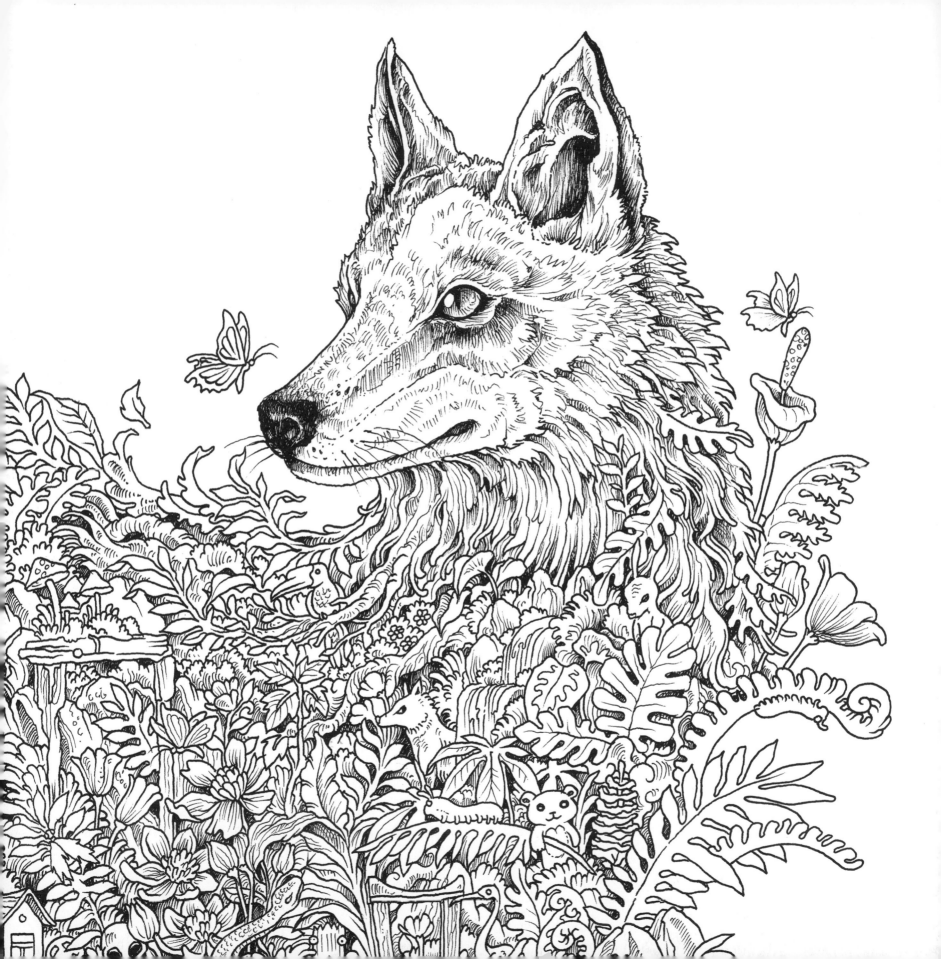

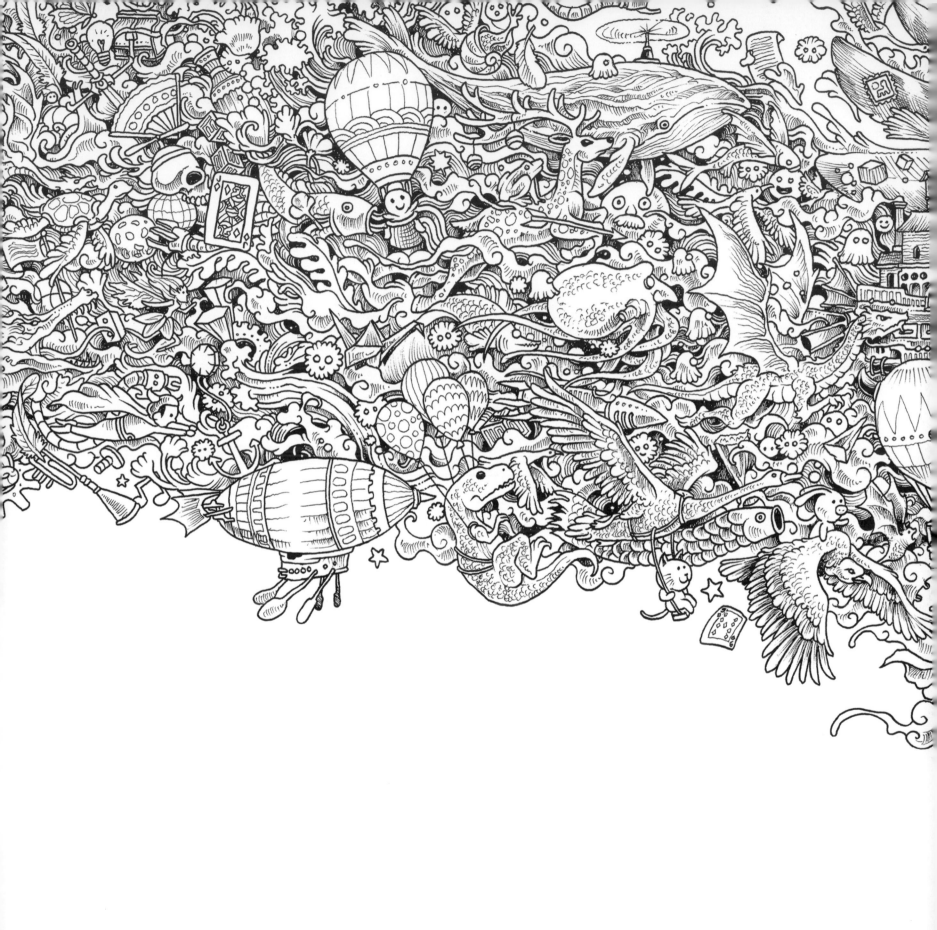

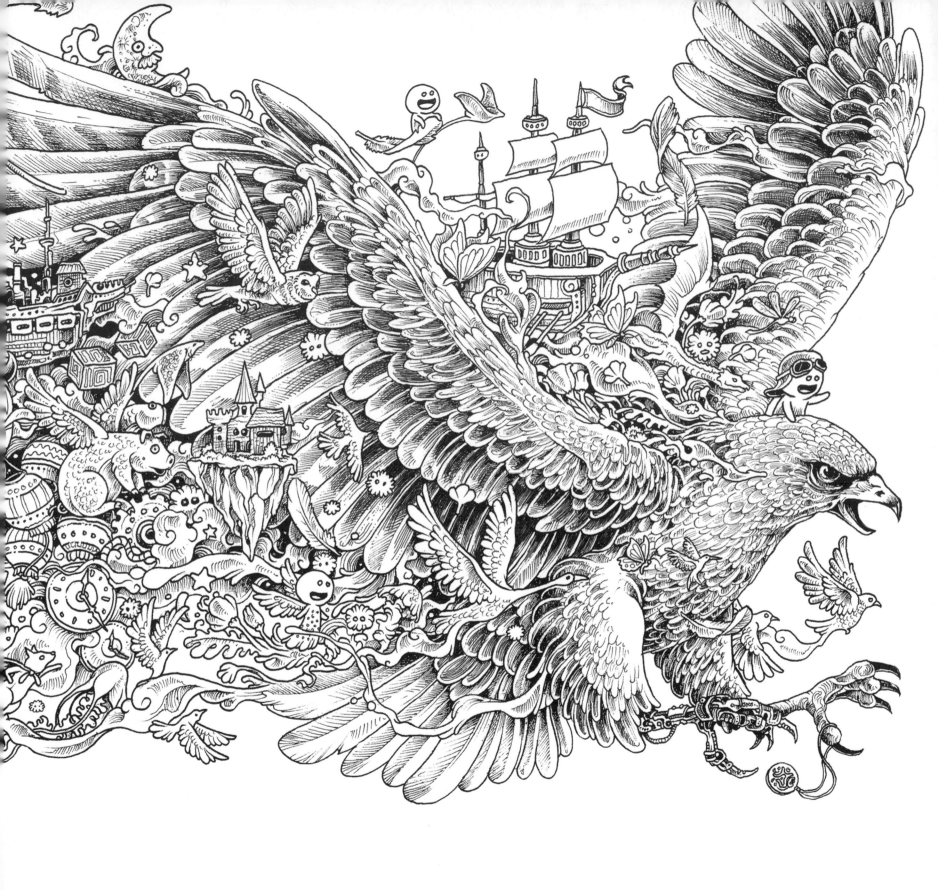

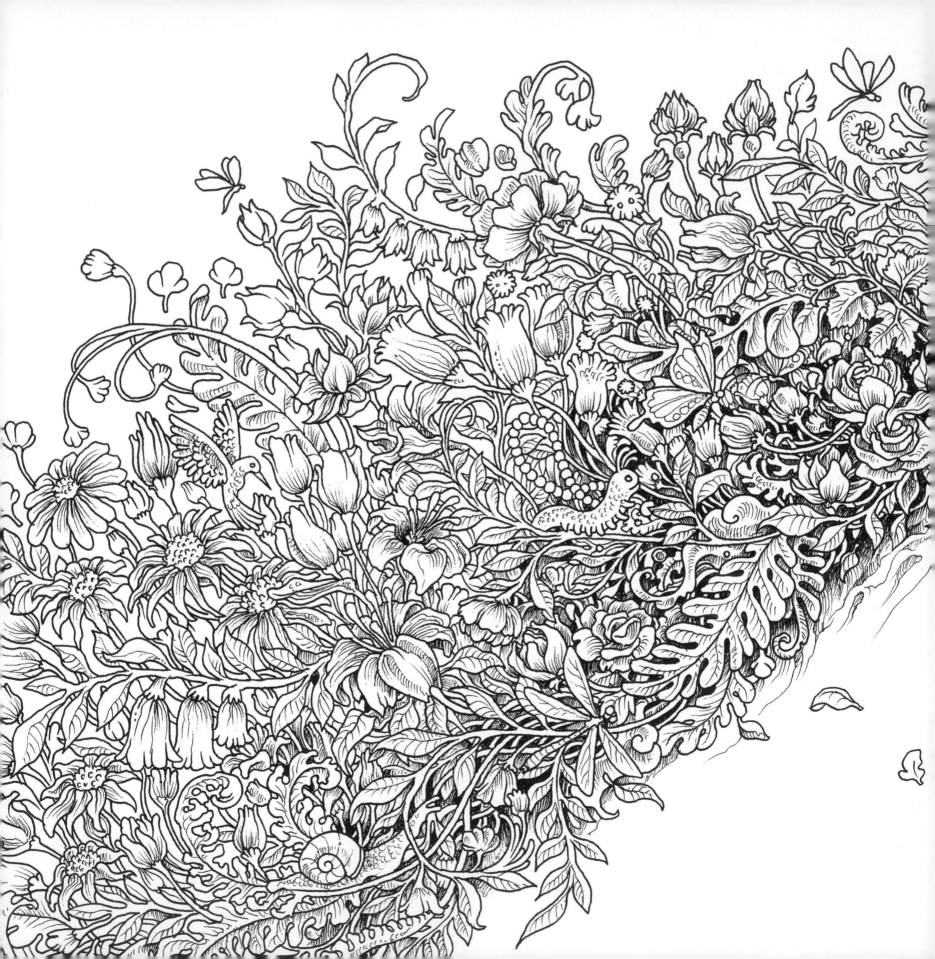

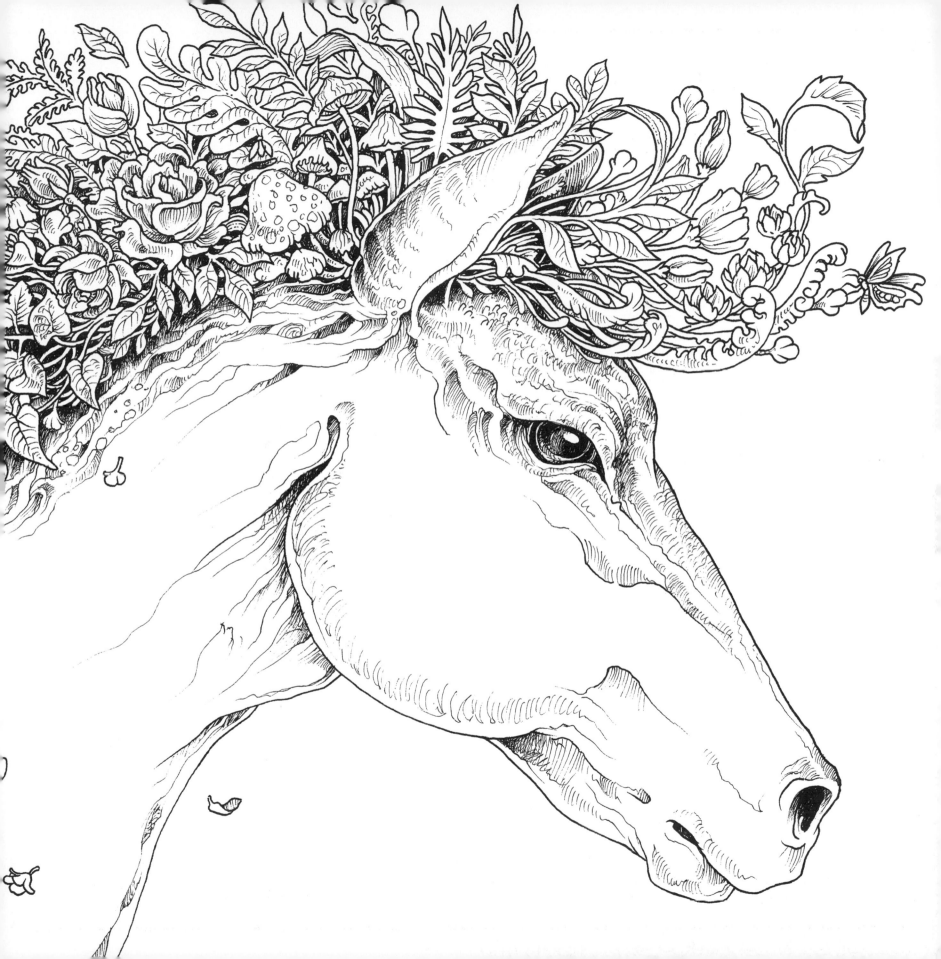

Can you find these items, artifacts, and creatures in the book?

When you have discovered them, color in the objects on the next few pages.

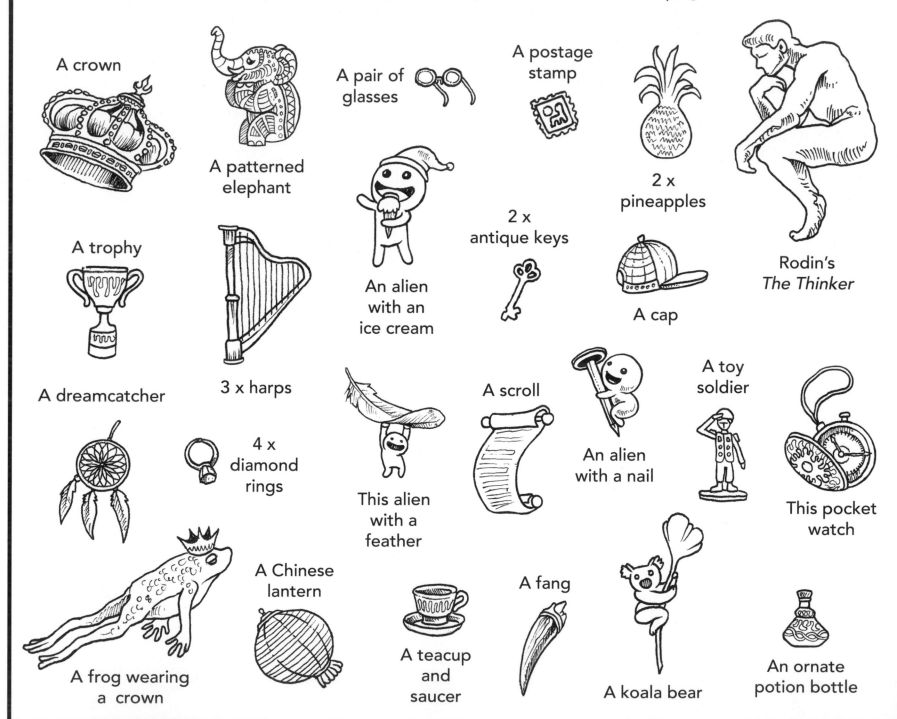

A crown

A patterned elephant

A pair of glasses

A postage stamp

2 x pineapples

Rodin's *The Thinker*

A trophy

An alien with an ice cream

2 x antique keys

A cap

A dreamcatcher

3 x harps

4 x diamond rings

This alien with a feather

A scroll

An alien with a nail

A toy soldier

This pocket watch

A frog wearing a crown

A Chinese lantern

A teacup and saucer

A fang

A koala bear

An ornate potion bottle

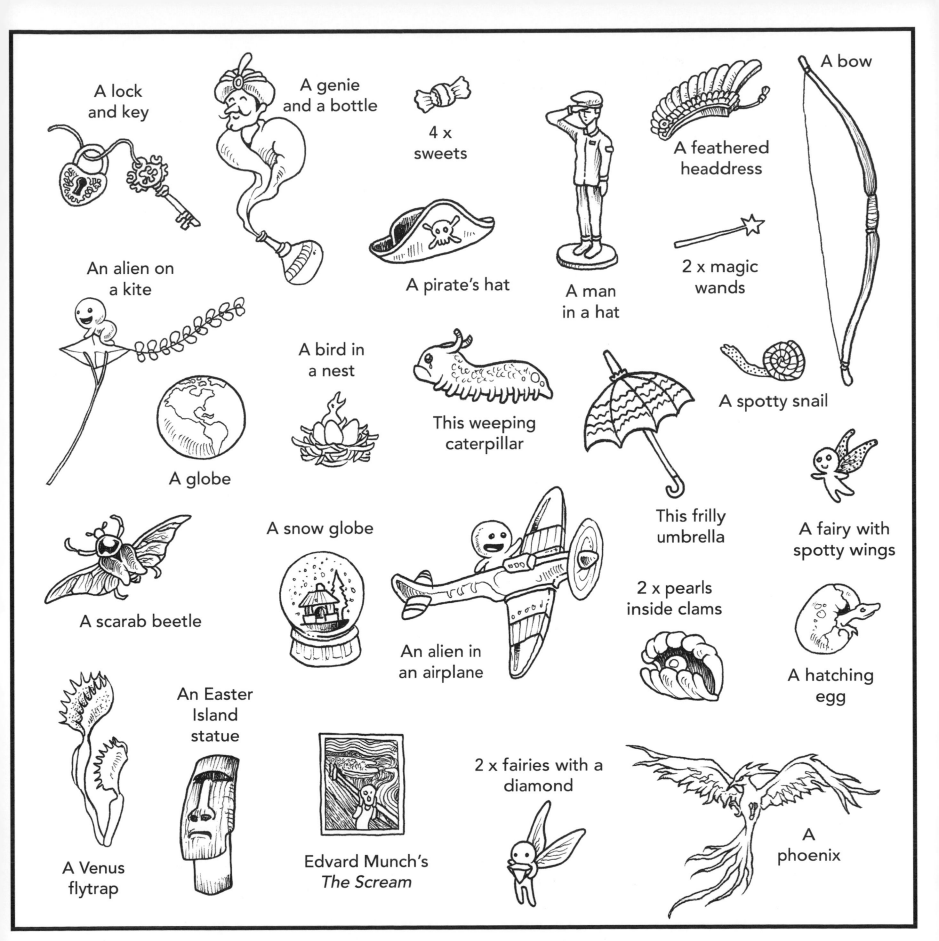

A lock and key

A genie and a bottle

4 x sweets

A man in a hat

A feathered headdress

A bow

A pirate's hat

2 x magic wands

An alien on a kite

A bird in a nest

This weeping caterpillar

A spotty snail

A globe

This frilly umbrella

A fairy with spotty wings

A scarab beetle

A snow globe

An alien in an airplane

2 x pearls inside clams

A hatching egg

A Venus flytrap

An Easter Island statue

Edvard Munch's *The Scream*

2 x fairies with a diamond

A phoenix

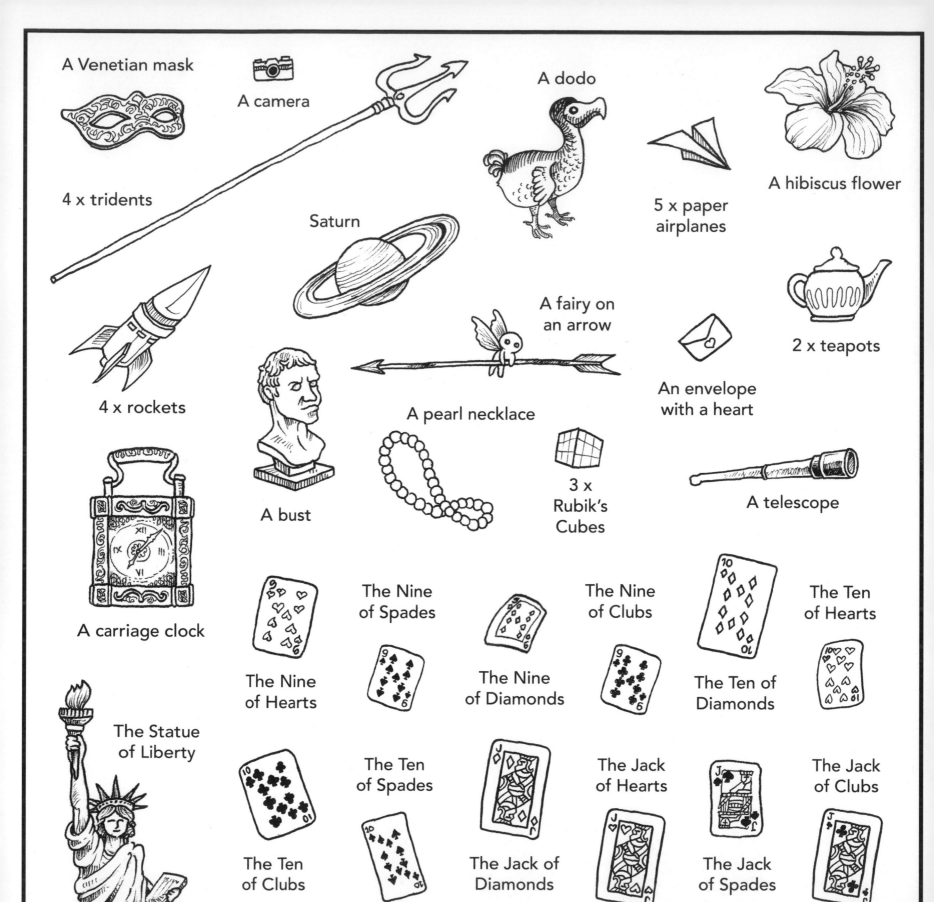

A Venetian mask

A camera

4 x tridents

Saturn

A dodo

5 x paper airplanes

A hibiscus flower

4 x rockets

A fairy on an arrow

2 x teapots

An envelope with a heart

A bust

A pearl necklace

3 x Rubik's Cubes

A telescope

A carriage clock

The Statue of Liberty

The Nine of Hearts

The Nine of Spades

The Nine of Diamonds

The Nine of Clubs

The Ten of Diamonds

The Ten of Hearts

The Ten of Clubs

The Ten of Spades

The Jack of Diamonds

The Jack of Hearts

The Jack of Spades

The Jack of Clubs

All the
Answers

The Jack of Clubs and a scroll

The Ten of Hearts and a
Rubik's Cube

A toy soldier

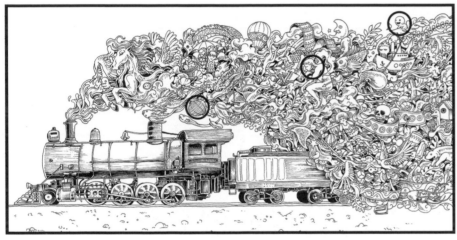

A Chinese lantern, Rodin's *The Thinker*, and an alien on a kite

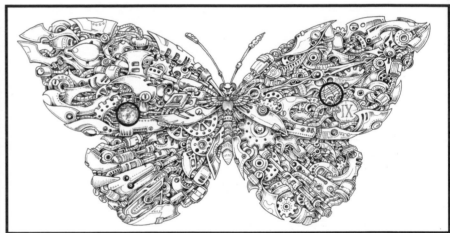

A carriage clock and a frilly umbrella

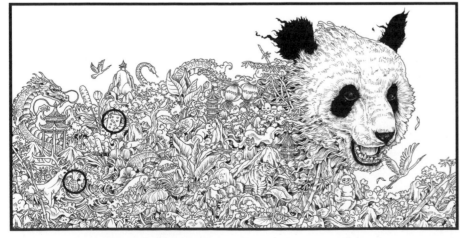

A pineapple and the Nine of Hearts

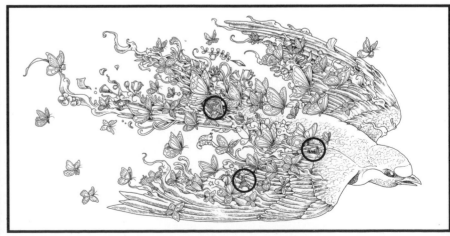

Edvard Munch's *The Scream*, an ornate potion bottle,
and a telescope

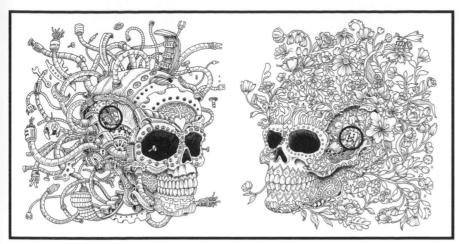

A pocket watch and the Nine of Clubs

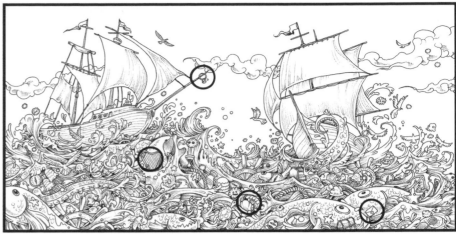

A harp, a diamond ring, a pearl inside a clam,
and an envelope with a heart on it

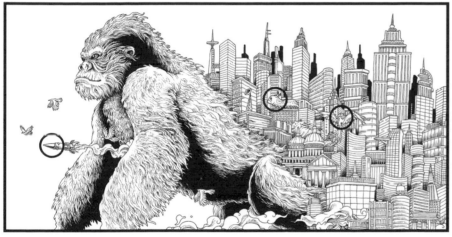

A rocket, a weeping caterpillar, and a phoenix

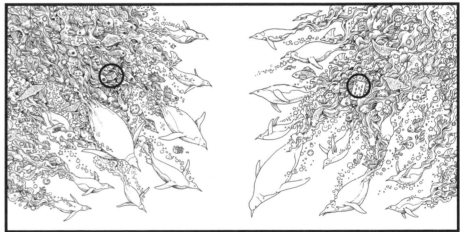

A Rubik's Cube and the Ten of Diamonds

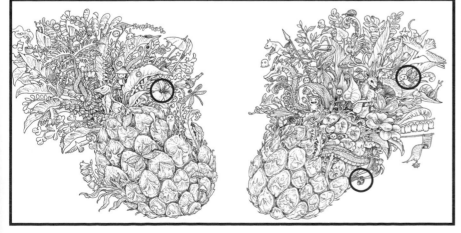

A hibiscus flower, a diamond ring, and
a fairy with spotty wings

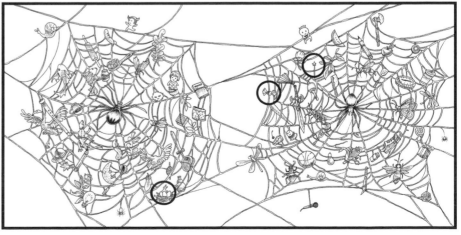

A bird in a nest, a sweet, and a magic wand

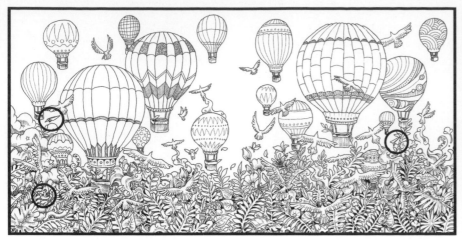

A koala bear and two paper airplanes

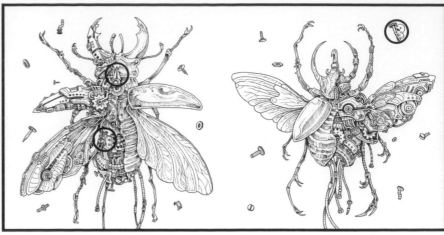

An antique key, a paper airplane, and an alien with a nail

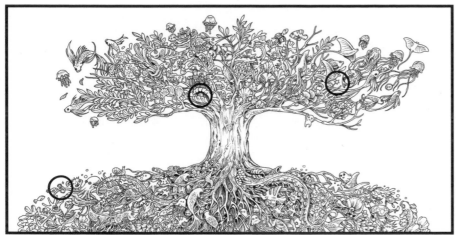

A diamond ring, a pearl inside a clam, and a magic wand

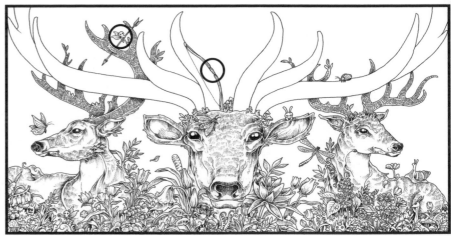

A fairy on an arrow and a bow

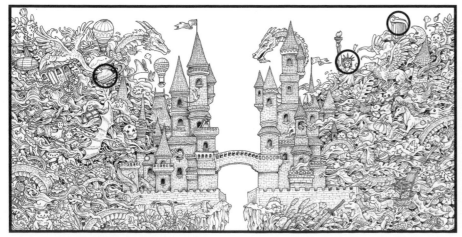

Saturn, the Statue of Liberty, and a harp

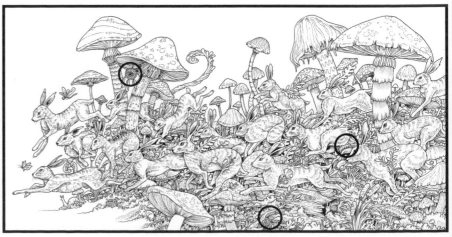

A dreamcatcher, a spotty snail, and a Venus flytrap

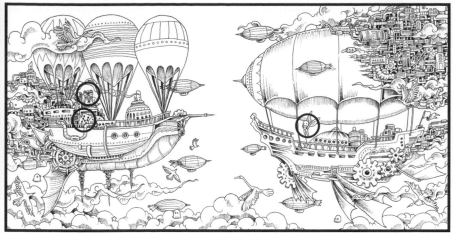

The Nine of Spades, a camera, and a fairy with a diamond

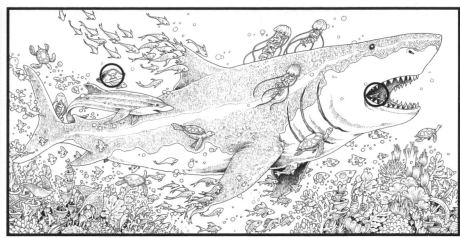

A pirate's hat and an antique key

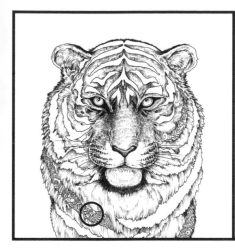

A sweet

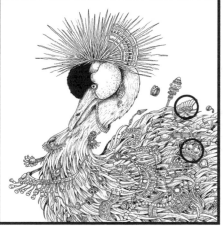

A feathered headdress
and a crown

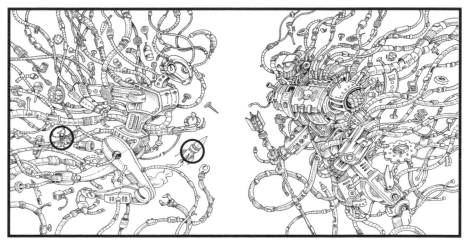

A scarab beetle and a rocket

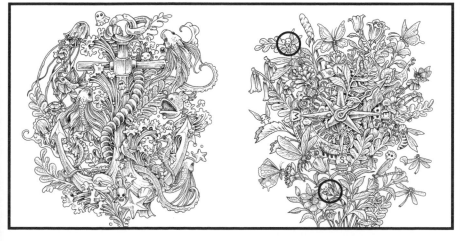

A fairy with a diamond and a diamond ring

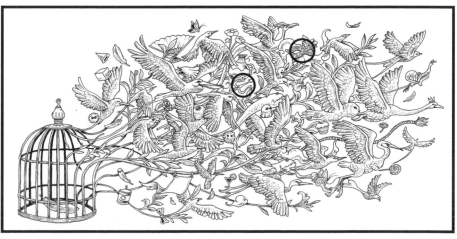

A trident and a Venetian mask

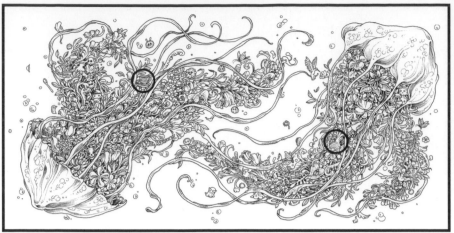

A teacup and saucer and a pineapple

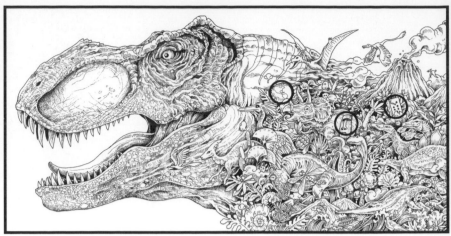

A globe, an Easter Island statue, and the Ten of Spades

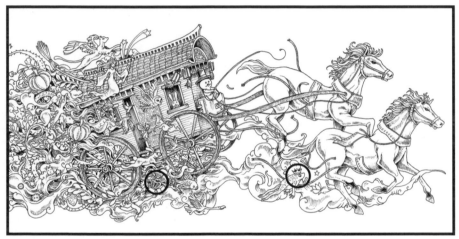

A lock and key and a frog wearing a crown

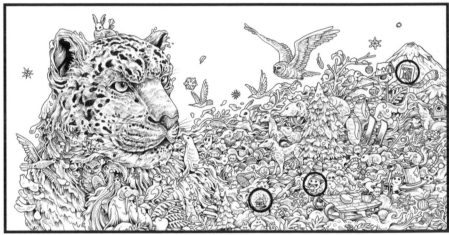

A snow globe, an alien with an ice cream, and the Jack of Hearts

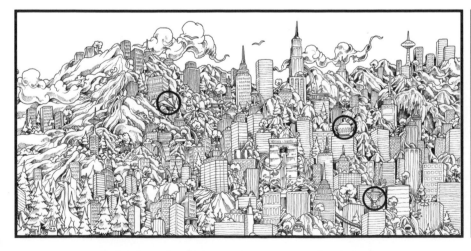

A paper airplane, a teapot, and a trophy

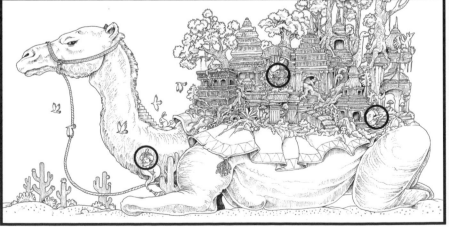

A genie and a bottle, a patterned elephant, and a hatching egg

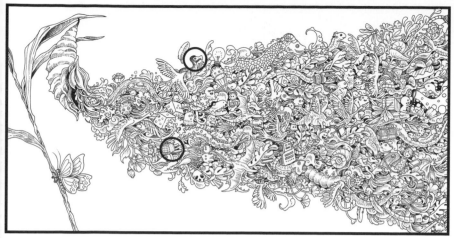

A cap and a dodo

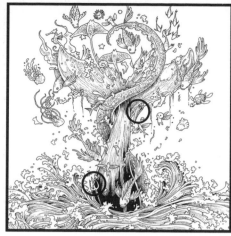

A fang and a trident

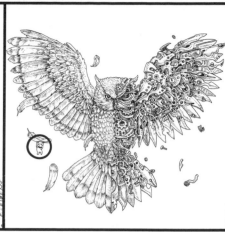

An alien with a feather

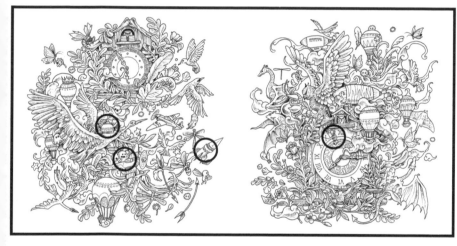

A teapot, an alien in an airplane, a rocket, and a sweet

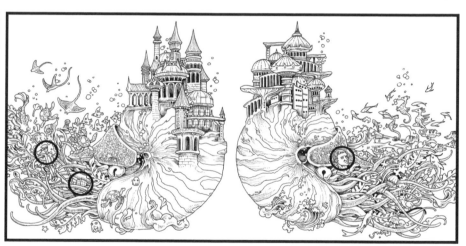

A man in a hat, a Rubik's Cube, and a bust

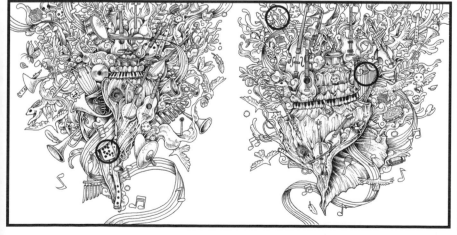

The Ten of Clubs, a trident, and a harp

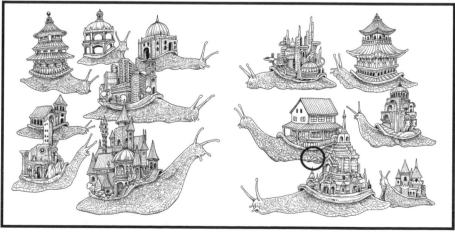

A paper airplane

A sweet and a pair of glasses

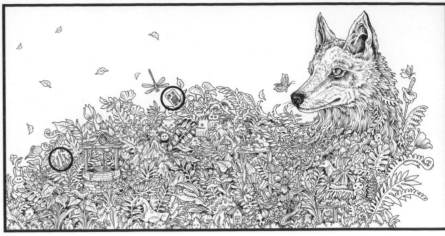

A trident and the Jack of Spades

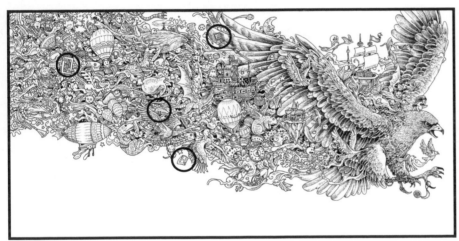

The Jack of Diamonds, a rocket, a postage stamp,
and the Nine of Diamonds

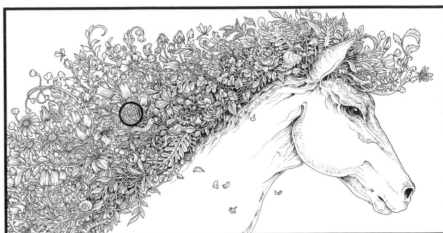

A pearl necklace

The end

Share your creations:
#imagimorphia